Remembering
North Carolina

Wade G. Dudley

TURNER
PUBLISHING COMPANY

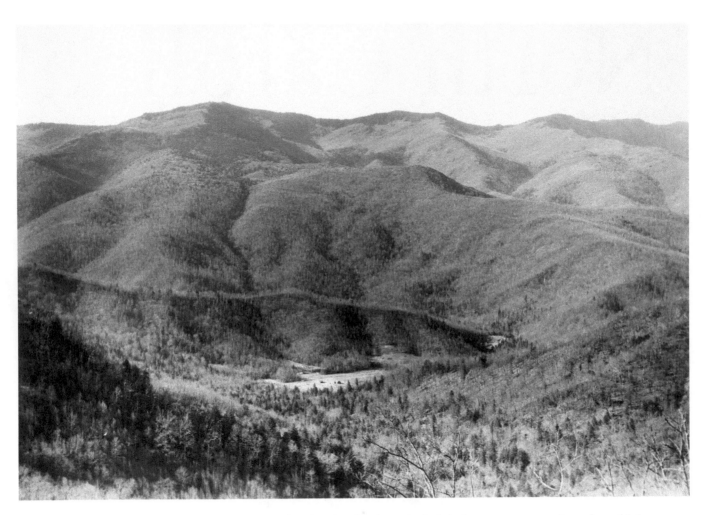

By 1860, much of North Carolina remained undeveloped and isolated, particularly in its western mountains, where this image of Lake Lure and Mount Mitchell bears little resemblance to the center of tourism existing today. According to the census of that year, the entire population of the state numbered fewer than a million people—661,563 free citizens and 331,099 slaves—and Wilmington, the state's largest urban area, held only 9,553 souls.

Remembering
North Carolina

Turner Publishing Company
4507 Charlotte Avenue • Suite 100
Nashville, Tennessee 37209
(615) 255-2665

Remembering North Carolina

www.turnerpublishing.com

Copyright © 2010 Turner Publishing Company

Library of Congress Control Number: 2010926218

ISBN: 978-1-59652-695-2

Printed in the United States of America

ISBN-13: 978-1-68336-862-5 (pbk)

CONTENTS

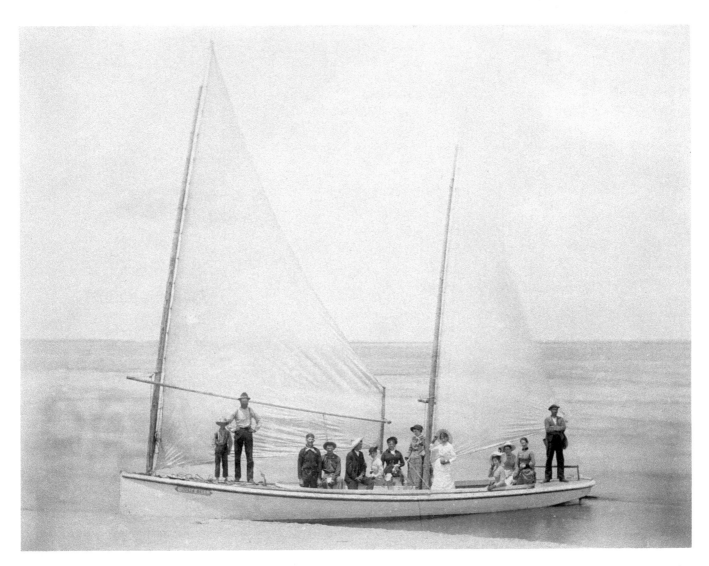

A family excursion on the *Julia Bell* in the 1880s provides a break from the workaday world. For most families along the miles of rivers, sounds, and sea in North Carolina, small craft were a necessity. They provided effective transportation where roads did not reach, brought food to the table, and provided extra income when surplus fish and shellfish made their way to local markets.

ACKNOWLEDGMENTS

This volume, *Remembering North Carolina,* is the result of the cooperation and efforts of many individuals and organizations. It is with great thanks that we acknowledge the valuable contribution of the following for their generous support:

Library of Congress
North Carolina State Archives

As always, the helpful staff of the Verona Joyner Langford North Carolina Collection at East Carolina University met my needs for data, both great and (sometimes) a little odd. Special thanks go to my teaching assistant for 2007–2008, Ms. Monica Ayhens, and to the numerous students in my North Carolina history classes who constantly challenge and inspire me to learn even more about this great state.

—*Wade G. Dudley*

PREFACE

The first permanent English settler of record in the lands that became North Carolina was Nathaniel Batts from the Virginia Colony. In 1655, he established a fur-trading post at the confluence of the Roanoke and Chowan rivers. Other Virginians followed, bringing with them the institution of slavery. By 1776, the Royal Colony of North Carolina claimed colonists of numerous origins, from freedmen to Scots Highlanders to Moravian Germans, with some two dozen languages and dialects, at least, scattered from coast to mountains. No matter the language spoken, those who remained in the colony in the years following April 12, 1776, and adoption of the Halifax Resolves agreed that North Carolina would be free of British rule. Thus the colony became a state, and the state became part of a great nation.

The Old North State, as it came to be called, had another nickname in its early years: the Rip Van Winkle State. It seemed to be asleep, trapped in a stagnant agricultural system of yeoman and subsistence farmers dominated by plantation owners in the coastal regions and river valleys. Slowly, that began to change with the introduction of a textile industry and improvements to the state's transportation infrastructure, notably the building of railroads and the use of steamships.

On the eve of the Civil War, North Carolina remained underindustrialized and absolutely dependent upon agriculture, especially cotton, for revenue. However, with only a quarter of its families owning one or more slaves and few plantations to rival those of Virginia and South Carolina, the state initially resisted abandoning the Union for the new-fledged Confederacy. The secession of Virginia and President Lincoln's call for troops from North Carolina to actually march into its sister states overcame that resistance; most North Carolinians would not fire on their Southern brothers. So war came to the state, bringing with it another sobriquet: Tar Heels, for the tenacity of North Carolinians on the battlefield became well known.

With the exception of cropping images where needed and touching up imperfections that have accrued over time, no changes have been made to the photographs in this volume. The caliber and clarity of many photographs are limited by the technology of the day and the ability of the photographer at the time they were made. Before the Civil War, and even during it, few photographs of North Carolina existed (or survived in reproducible form) other than portraits, so the 1860s became a logical starting point for this photographic study. As the decades crawled along, the number of photographs available increased dramatically, thus the challenge became selecting those images that would reproduce clearly while still telling the story of this marvelous state and its people. Even then, there were problems, as many photographs had been snapped at random or else lacked identifiers, while some key issues in state history either never received the attention of a photographer or the related photographs remain unavailable in private collections.

Thus this book is a history, of sorts, but a history told primarily with photographs: random seconds in time frozen forever by the flash of a camera. Words can be twisted, but these images offer a very solid reality of their own. This is, of course, a study of change, and I have made little effort to provide it with a thematic structure—other than change itself. And though I have provided some background and interpretation of the photographs (and accept the responsibility for any errors therein), I urge you to let the pictures tell their own story of our beloved Old North State.

—*Wade G. Dudley*

Two crewmen stand on a quay in Washington, locally known as "Little Washington," alongside their oystering boat in 1884. The introduction of refrigerated railcars in the 1870s and refrigerated cargo vessels in the 1880s meant new markets for shellfish from the Carolina sounds. In modern times, overfishing and pollution have reduced this delicious bounty.

Civil War and Recovery

(1860s–1899)

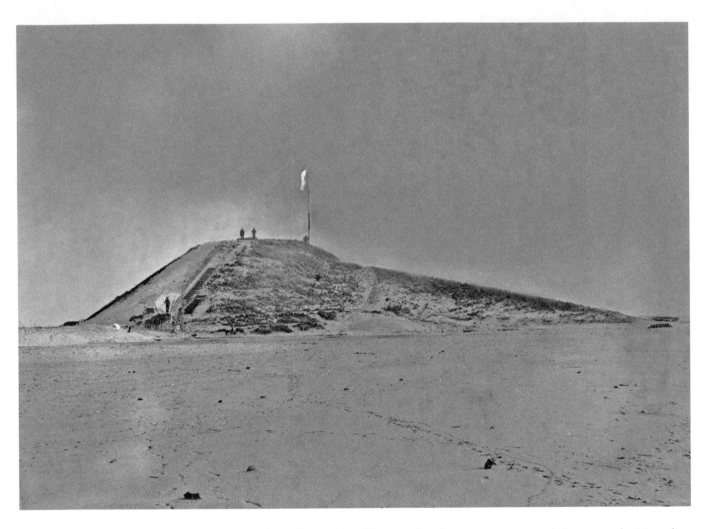

Battery Lamb, named for Fort Fisher's commanding officer, Colonel William Lamb, was more commonly known as the Mound Battery. It anchored the mile of traverses on the seaward side of Fort Fisher. Built in the spring of 1863 and topped by powerful rifled cannons, the structure towered 43 feet above the waters that it guarded. In November 1863, President Jefferson Davis of the Confederacy visited the fort and received a 21-gun salute as he reached the summit of this impressive fortification.

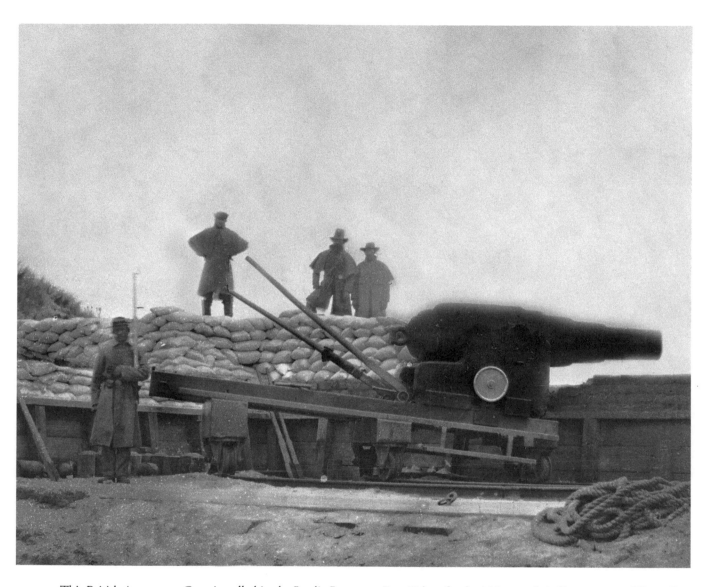

This British Armstrong Gun, installed in the Purdie Battery at Fort Fisher, fired a 150-pound shell to a range of five miles. Captured when the fort finally fell to the Union in January 1865, the gun became the centerpiece of the United States Military Academy's Trophy Point. The Academy lent the gun to the Fort Fisher Historical Site for display from 2004 to 2006 to commemorate the 140th anniversary of the battles at Fort Fisher.

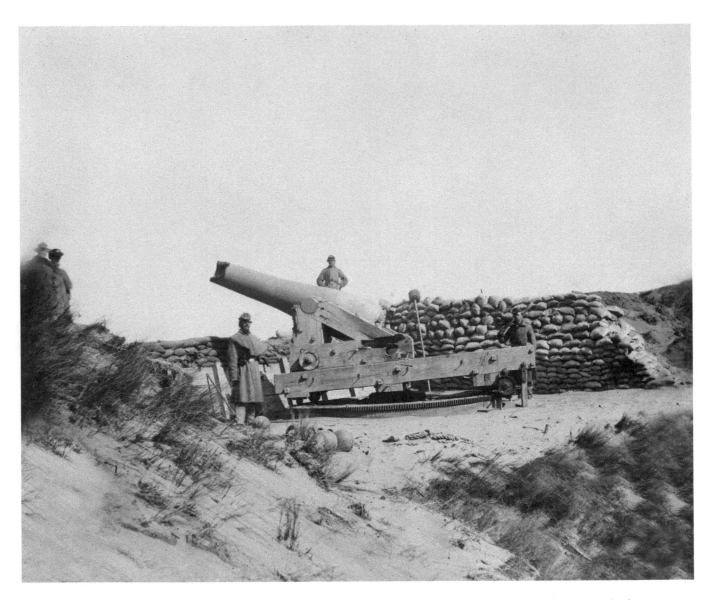

Though the Union bombardment silenced a number of Fort Fisher's guns (in this case, the entire muzzle is missing), the fortification hailed as the Gibraltar of the South didn't fall until January 15, 1865. Fort Fisher mustered only 1,500 defenders to repel the 10,000 Union troops concentrated against it. The loss of the fortress and its gallant regiments meant the immediate fall of Wilmington, the cutting of the Army of Northern Virginia's supply line, and the fall of the Confederacy three months later.

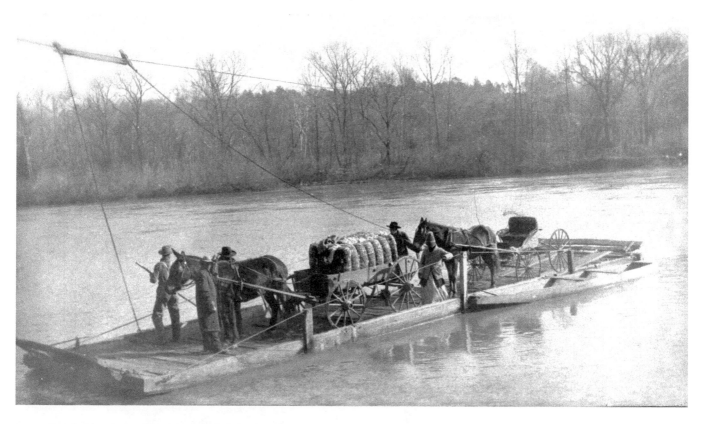

Few bridges existed over North Carolina's rivers in the 1800s, and spring freshets frequently swept away those that did. Most areas relied on cable-ferries, such as the one across the Yadkin River on the border of Stanley and Montgomery counties in the Piedmont. This ferry continued service until 1922 and the opening of the Swift Island Bridge, itself replaced four years later when a hydroelectric dam created Lake Tillery.

An oxcart sits outside the western grounds of the Capitol in Raleigh sometime in the late 1880s. Completed in 1840, the building replaced the old statehouse, which was built in the 1790s and lost to fire in 1831. The Capitol housed all branches of the government until 1888, when the Supreme Court and State Library relocated. In 1963, the General Assembly moved to the new State Legislative Building. The lieutenant governor's office was moved to the historic Hawkins-Hartness House in 1969.

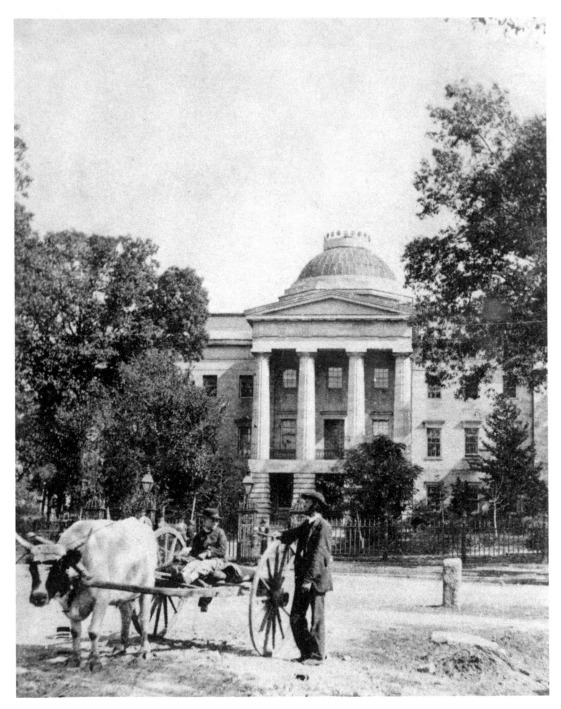

Following the Civil War, entire African-American communities, such as Princeville in Edgecomb County, appeared across the state. In towns and cities, unofficial segregation led to the growth of vibrant African-American districts. In Greensboro, Elm Street, pictured here in 1889 or 1890, marked the eastern edge of one such district, Warnersville, while Lee Street demarcated its northern boundary. By 1900, segregation had become the law of the land.

Farmers haul their cotton and other products to market at Charlotte in 1890. The value of crops in North Carolina had fallen since 1870. Their desperate situation persuaded farmers to organize as the Populist Party, led by Marion Butler of Sampson County. He formed an uneasy alliance with Republicans under Daniel Russell of New Hanover County. This "Fusion" coalition ousted the Democratic Party from power in North Carolina in 1894.

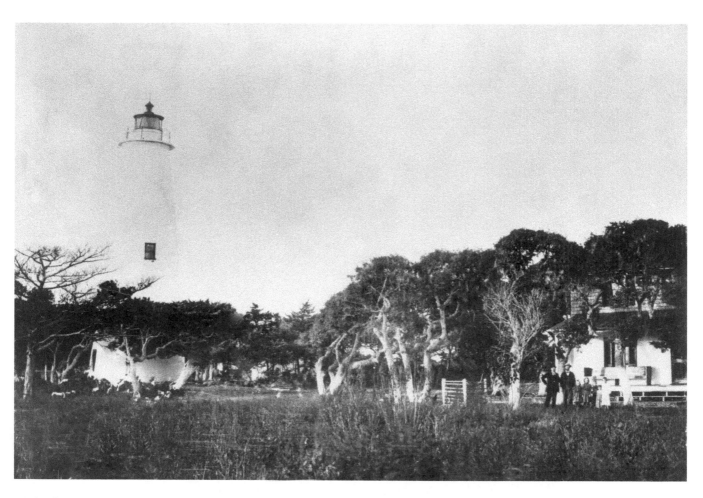

The dangerous coastal waters of North Carolina forced the United States to build lighthouses rather than add to the tremendous tally of ships lost to an area called the Graveyard of the Atlantic. The Ocracoke Lighthouse, pictured in 1890, was the third structure to guard Ocracoke Inlet, replacing a wooden tower built in 1798 and a lightship used in the early 1820s. Standing 75 feet tall, the lighthouse guided many a weary mariner home.

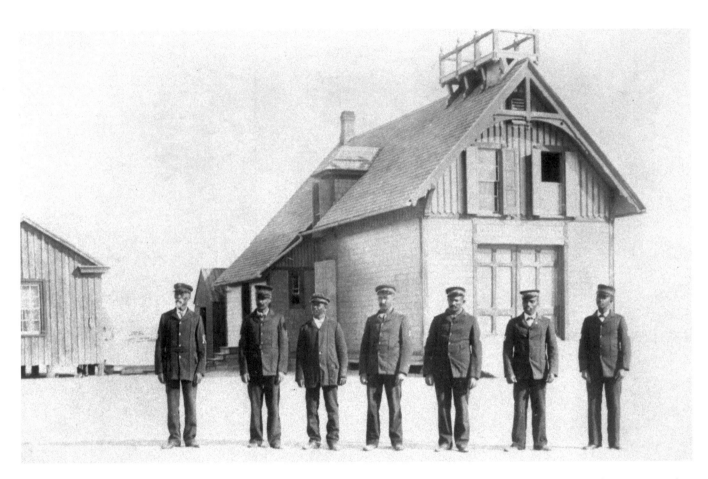

In 1880, the superintendent of the United States Life-Saving Service appointed surfman Richard Etheridge, at left, to command the Pea Island Life Station, seen here in the late 1890s. Segregation dictated that he hire an all black crew. In 1996, the original surfmen and Etheridge received posthumous Gold Lifesaving Medals for the 1896 rescue of the *E. S. Newman*. The station closed after World War II.

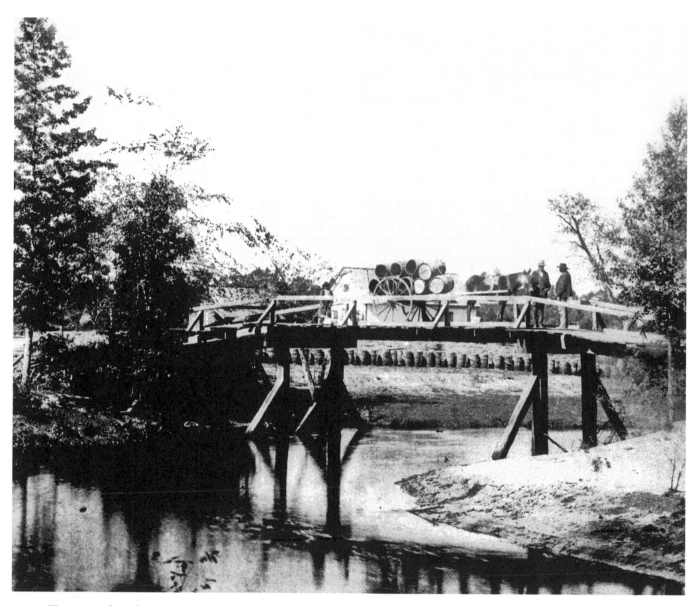

Turpentine barrels cross Boykin's Bridge in Sampson County in 1890 as part of their journey to market. Loaded onto a flat-bottomed steamer on the Black River, they would then travel downstream to the Northeast Cape Fear and on to Wilmington, probably to the docks of Worth & Worth. Transshipped to seagoing vessels, the turpentine could eventually be used in any corner of the world.

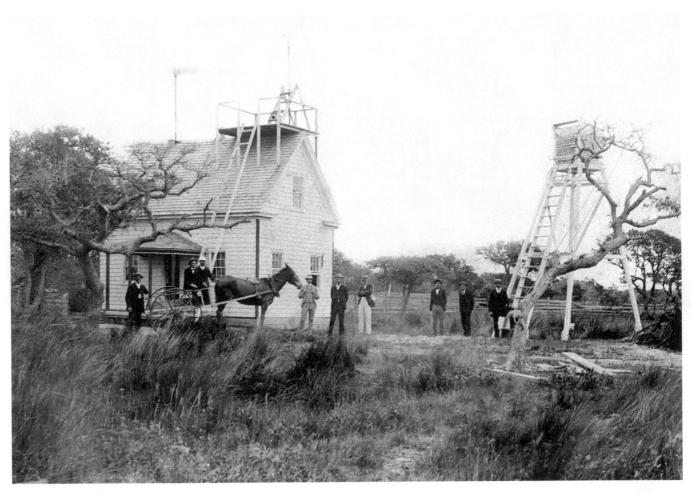

The United States Weather Bureau established a station at Hatteras Village in 1874. Connected by telegraph to Washington, D.C., the station became a vital link in coastal forecasting. This picture from the late 1890s appears to feature the private dwelling used as the station before the bureau built its first official building in 1901.

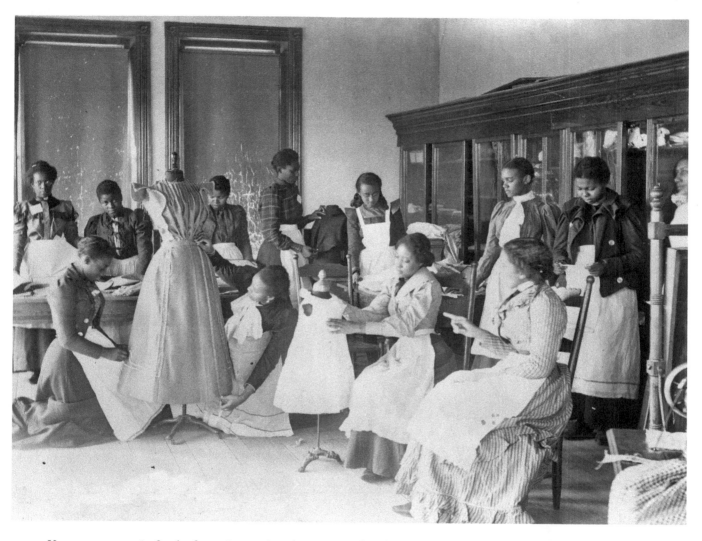

Young women train for the future in a sewing class at Agricultural and Mechanical College in Greensboro. This photograph formed part of the American Negro Exhibit at the Paris Exposition of 1900. *Plessy v. Ferguson* (1896) guaranteed "separate but equal," but segregation meant that black women and men, even with degrees in hand, could not be truly equal to similarly educated whites in terms of rights and opportunity.

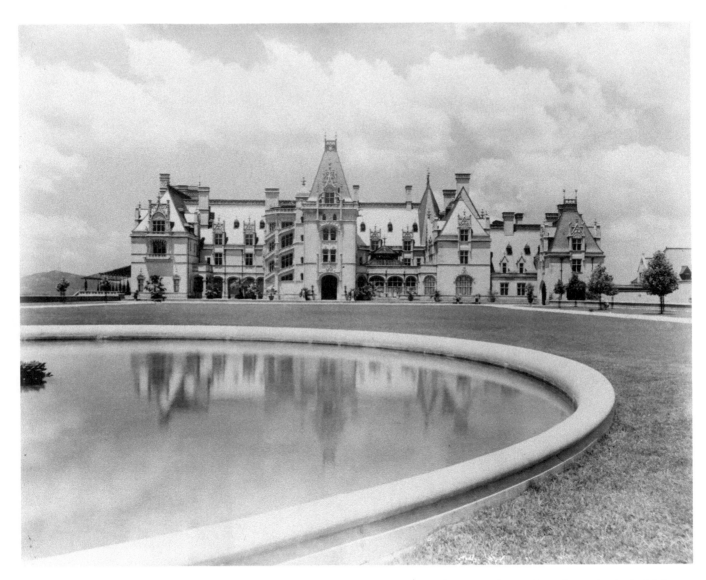

A true gem of the North Carolina highlands, the Biltmore Estate, seen here some five years after its formal opening in 1895, has long drawn tourists to the Asheville region. George Vanderbilt, son of the tycoon Cornelius Vanderbilt, purchased 125,000 acres for his estate near the town already known to high society as a health retreat. After his death, his wife donated almost 87,000 of those acres to the federal government to form Pisgah National Forest.

THE PROGRESSIVE DECADES

(1900–1919)

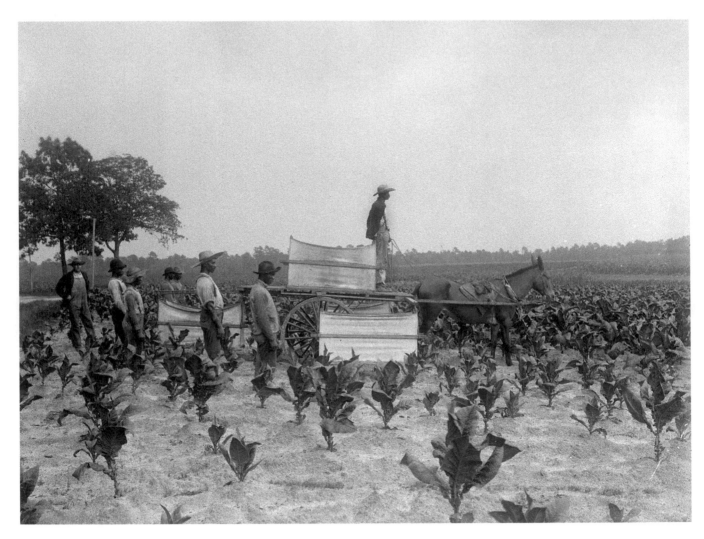

A crew prepares to "crop" tobacco on a Nash County farm in the early 1900s. They will remove the yellowing lower leaves from the plant and place them into the mule-powered "drag." At the barn, waiting hands will tie the leaves to tobacco sticks for curing, then grading, then delivery to market. Whether cropping tobacco or picking cotton, only hard work and low wages awaited field hands, black and white alike, in North Carolina.

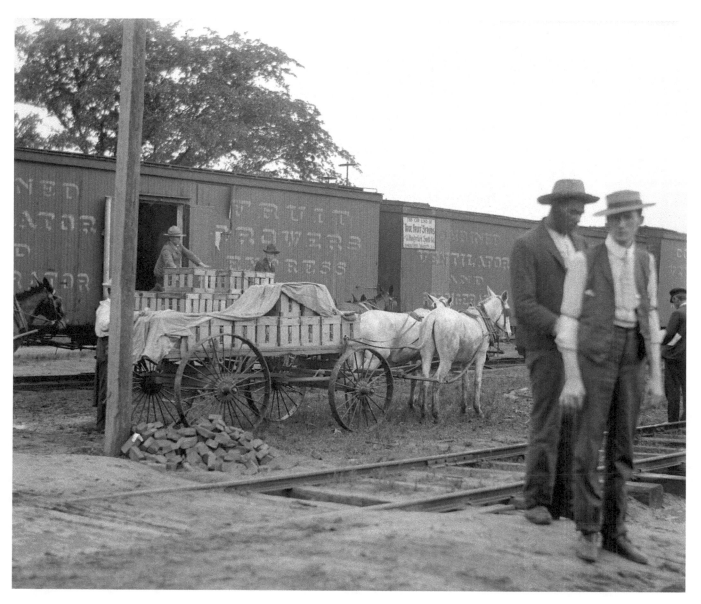

Just as they had once sprouted beside rivers, small towns grew where the iron rails ran. Farmers in Chadbourn, incorporated in 1883, needed a crop to replace the fading naval-stores industry. In 1895, they planted their first strawberry fields. By the time of this 1902 scene, Columbus County's strawberries graced shelves and tables everywhere. In 1926, the town established a yearly Strawberry Festival—now the oldest agricultural festival in the Tar Heel State.

17

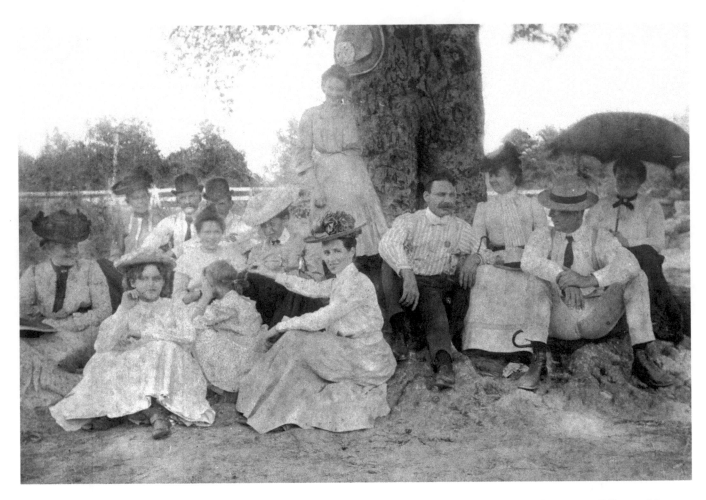

The Falls of the Neuse River was a popular destination for Raleigh citizens such as this extended family in 1902 (falls, resulting from a rapid rise in elevation, mark the end of navigation for a river). Such outings to this location ended in 1981 with the completion of the dam that created Falls Lake and covered the old picnic site.

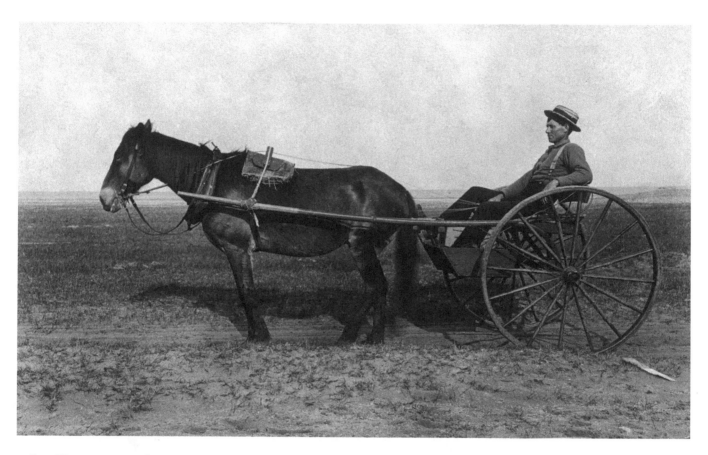

Cape Hatteras attracted attention in many ways. Those at sea watched for its lighthouse to avoid this southeast-thrusting portion of Hatteras Island and nearby Diamond Shoals—the heart of the Graveyard of the Atlantic. From the land came hearty tourists seeking solace in the beautiful desolation of Hatteras. Here, a man poses in 1902 in one of the many beach carts on the island.

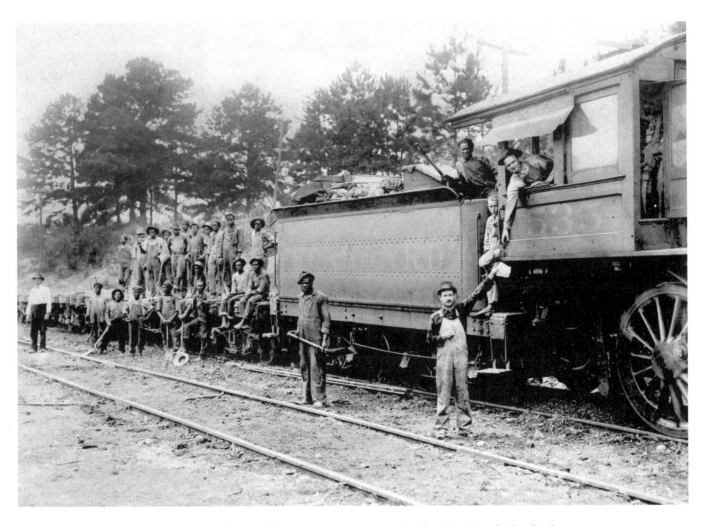

Engine 535 supports a work crew around 1905. The growing importance of railroads to North Carolina's economy meant more rails to place and constant maintenance of existing lines. The overwhelmingly African-American work crew (except for the "boss" at left) is typical of the segregated South of that time.

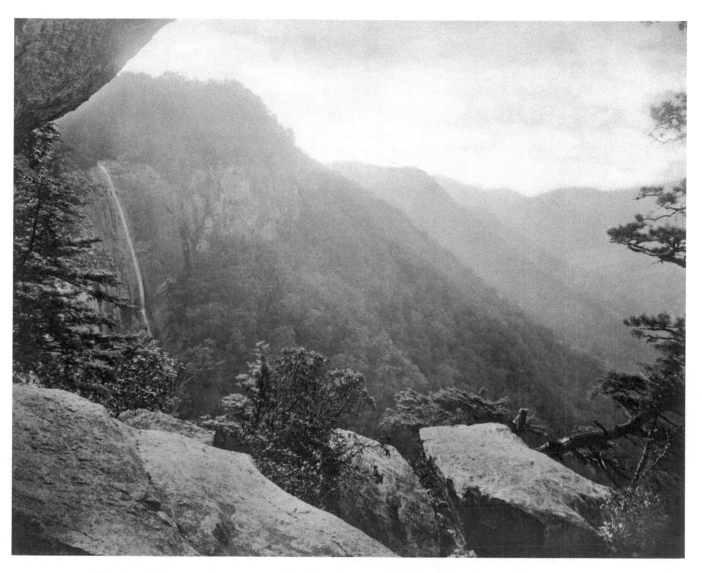

This beautiful mountain scene near Asheville, photographed in 1903, is only part of the reason the region drew the wealthy to vacation and build summer homes. Yellow fever had plagued coastal cities throughout the nineteenth century. Thus those who could afford it fled the cities every summer for the healthier climate in upland areas such as the mountains of the Old North State.

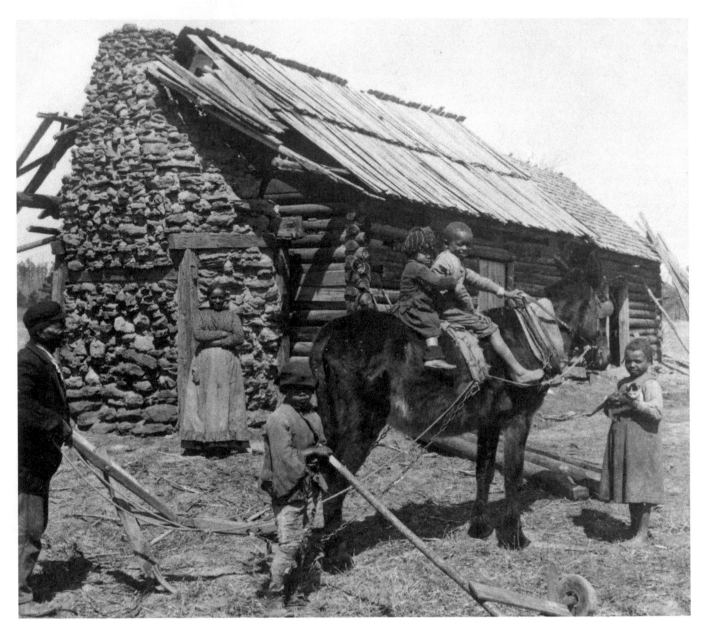

Though North Carolina gave every appearance of prosperity to those outside the state, prosperity always means hard work and very hard work for many. In the agricultural sector, sharecropping kept many blacks and poor whites in a perpetual cycle of debt and ignorance. The young children in this 1903 photograph taken outside their family's home had little chance to escape that life.

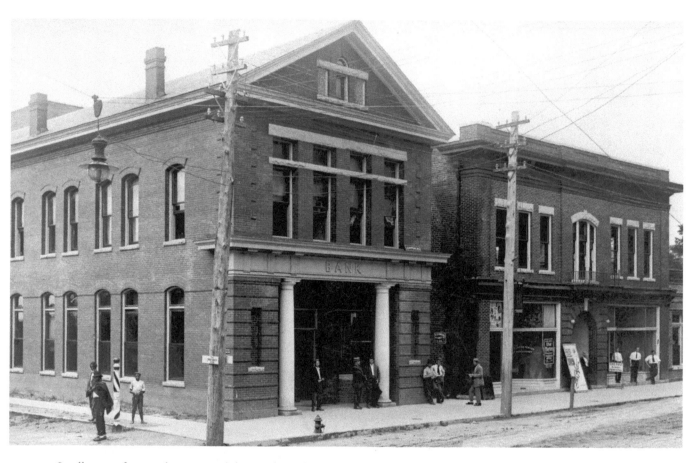

Small towns frequently prospered during the early twentieth century as railroads and light industry turned them into vital commercial centers supporting local agriculture. Small banks opened everywhere. Built in 1906 and seen here shortly thereafter, the Pee Dee Bank stood beside the Opera House on the corner of North Hancock and East Washington streets in Rockingham, in Richmond County. The building survives to this day, but the bank collapsed during the Great Depression.

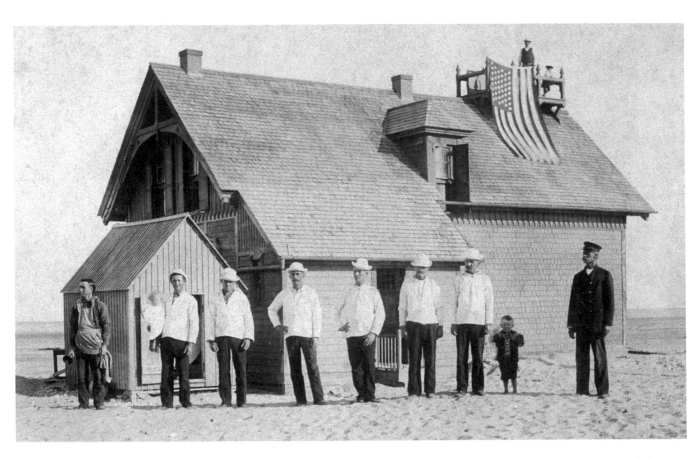

Another in the string of life-saving stations along the coast, Big Kinnakeet stood a few miles northeast of the Hatteras Lighthouse until the station's closure in the 1930s. Its keeper and surfmen won a Gold Lifesaving Medal in 1884 for the rescue of the crew of the *Ephraim Williams*. In this photograph taken sometime between 1900 and 1903, Keeper Amalek T. Gray stands at right.

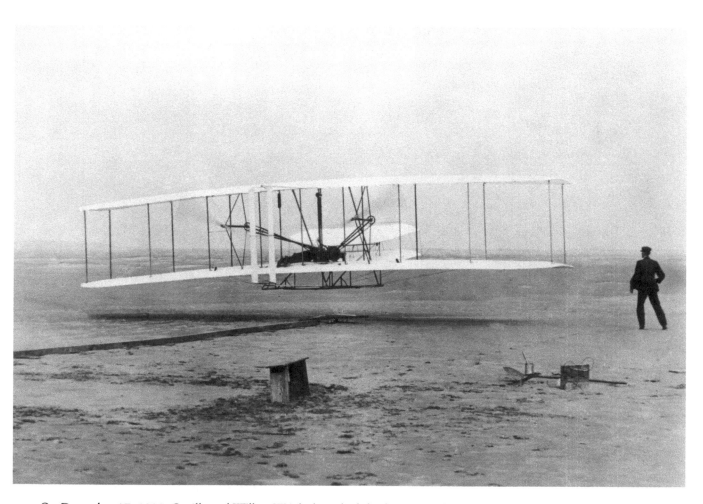

On December 17, 1903, Orville and Wilbur Wright launched the first manned, powered flight—of 12 seconds' duration—at Kitty Hawk. Thus North Carolina became "First in Flight." Today, the Wright Brothers Memorial marks and celebrates this historic achievement.

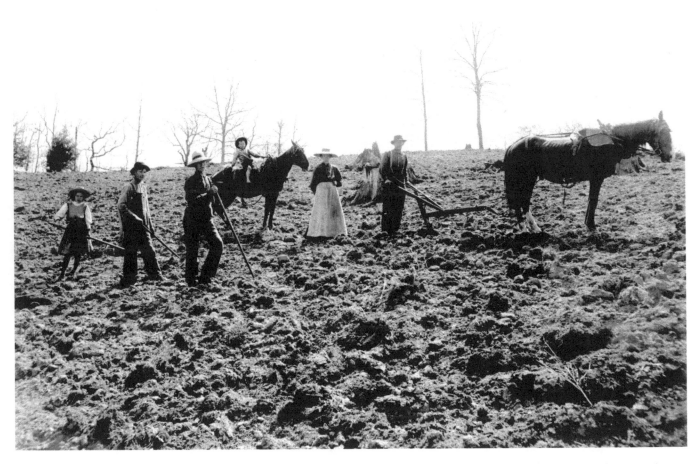

Though some farmers prospered in the early twentieth century, farming demanded long hours from the entire family, as on this farm near Linville Falls in 1905. Spring meant clearing land and planting; fall meant harvesting, canning, and taking crops to market. Only over the winter months could the farmer and his wife take a breather and the children attend school.

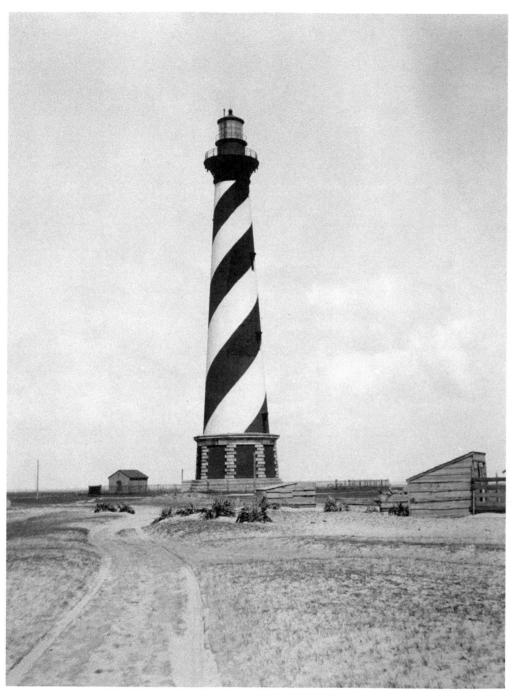

Completed in 1870 and pictured here in 1905, the Cape Hatteras Lighthouse towers 208 feet above Hatteras Island, making it the tallest lighthouse in the United States. By 1905, coastal erosion had brought the lighthouse to within 300 feet of destruction. Since that date, an epic battle for the structure's survival has been waged with the Atlantic breakers, culminating in the 1999–2000 removal of the entire lighthouse 2,870 feet inland—an epic feat of engineering.

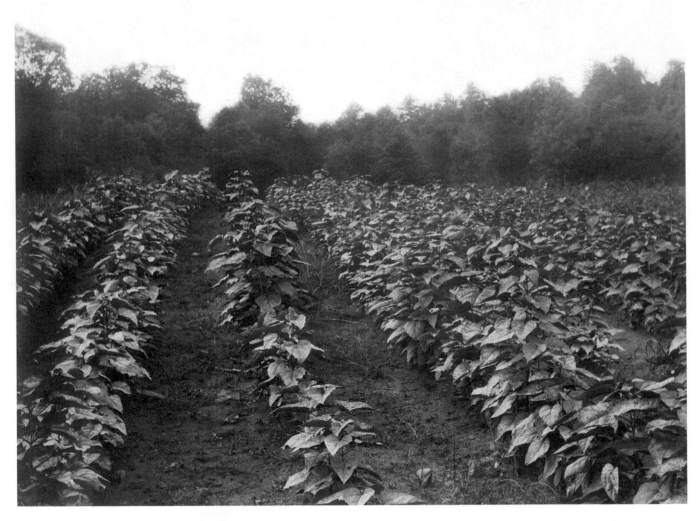

Bright leaf tobacco, pictured on the Cunningham farm in Person County in 1906, provided fuel for the North Carolina economy from Reconstruction through the 1990s. From such fields, the leaves traveled to local markets, then to processing plants and manufacturers throughout the state. With the decrease in production since the 1970s, it is easy to forget the smell of curing tobacco that once permeated late summer in much of the Old North State.

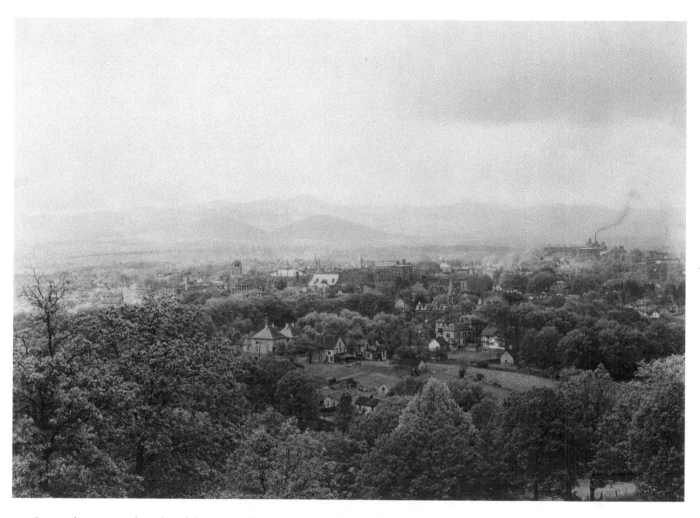

Just as the sun, sand, and surf drew the rich and famous to Wrightsville Beach, the wealthy also flocked to the other end of the state, especially to Asheville in Buncombe County. Sometimes called the Paris of the South (though other southern cities claim that title as well), Asheville became a haven for those wealthy enough to flee unhealthy city climates in summer during the early 1900s. This bird's-eye view dates to around 1908.

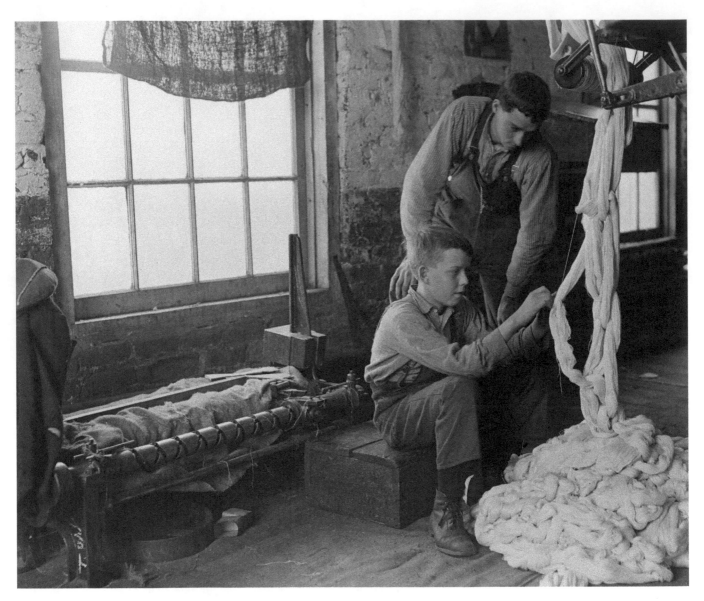

In December 1908, this boy, barely into his teens, feeds yarn to the warping machine that will align the strands for the loom at Clyde Cotton Mill in Newton, Catawba County. Mill workers started work as early as age five, running behind the looms to gather loose fibers. This fellow might eventually become a loom operator, but his lack of education meant he would rise no higher in the company.

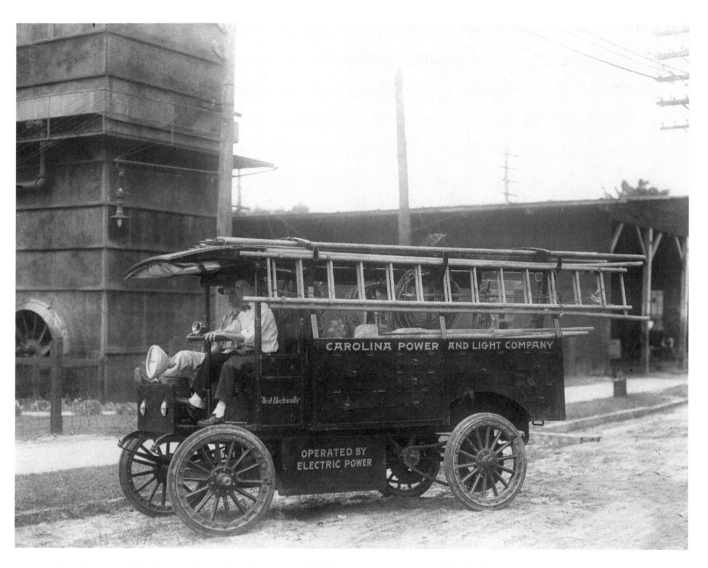

An electric-powered utility truck cruises the streets of Raleigh in 1909. One could also have found steam-powered cars on state roads in the early 1900s, though they had a 45-minute-plus warm-up time on cold mornings. By the mid-1930s, gas-powered vehicles had replaced other types.

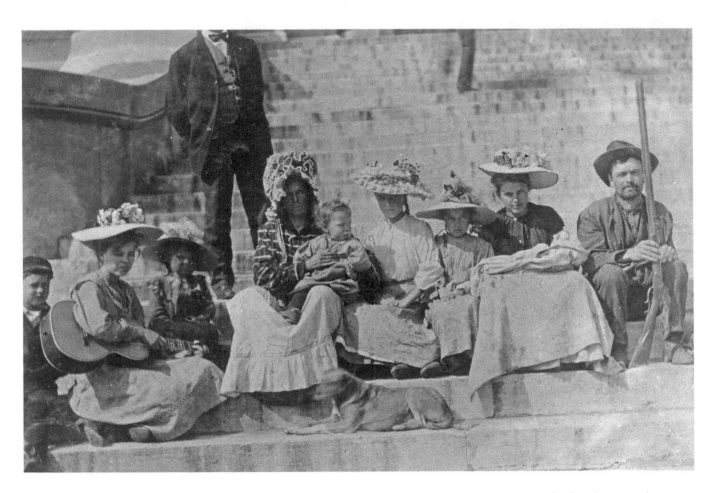

The Peuland family of Scaly Gap in Macon County posed for photographer Lewis Hine on the steps of a church or courthouse around 1909. In the early 1900s, bear and mountain lions (as well as humans with evil intent) in the underdeveloped region required traveling armed—even to church.

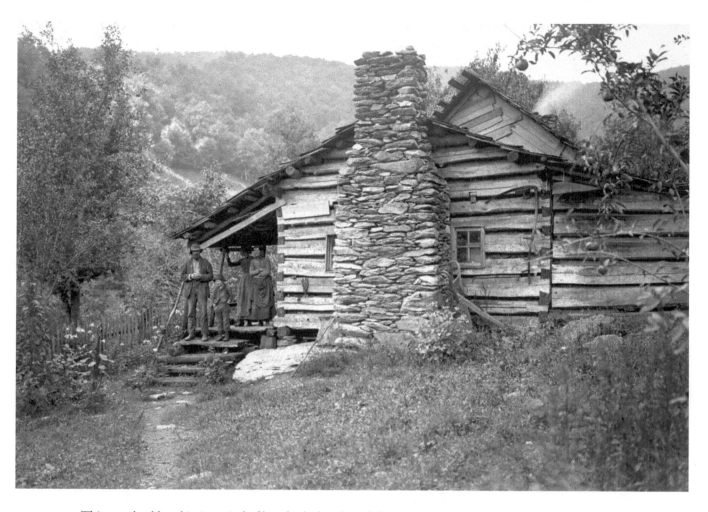

This ramshackle cabin is typical of hundreds that dotted the mountains of North Carolina in the early 1900s. Fiercely independent, desperately poor, and ill educated characterized most of those families.

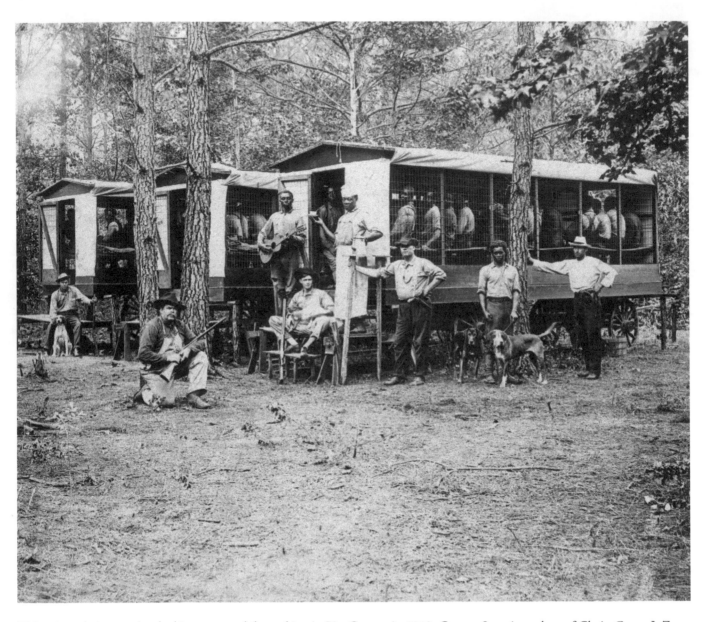

This prison chain gang bunked in wagons while working in Pitt County in 1910. County Superintendent of Chain Gangs J. Z. McLawhon, with the aid of bloodhounds, oversaw the prisoners.

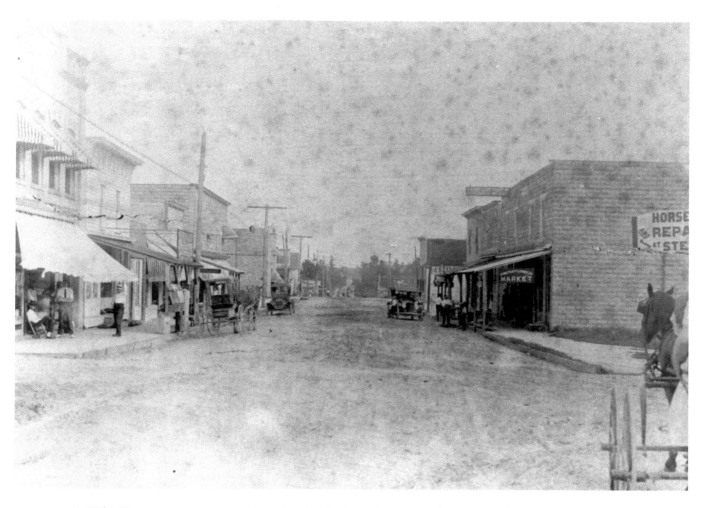

A Wake County stop on a railroad built in 1906, Zebulon incorporated in 1907 with a name honoring the governor of Confederate Carolina. In 1912, the town's unpaved main street saw as many horse apples as tire treads, while stables did more business than automobile mechanics. Electric lines reached the town but not necessarily the adjacent countryside. All in all, the sleepy hamlet typified many small towns in North Carolina in the early 1900s.

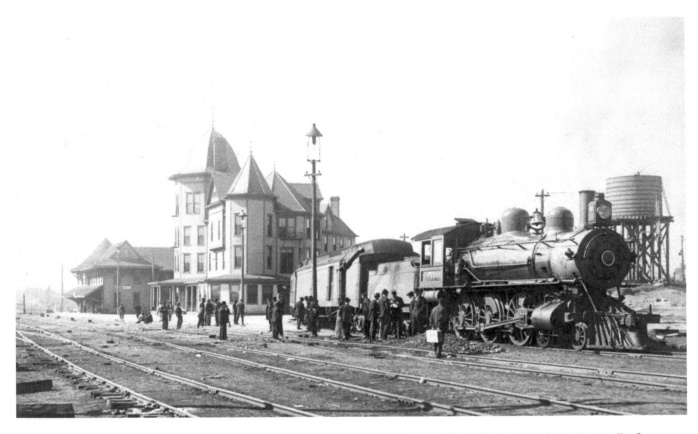

Hamlet, in Richmond County, incorporated in 1897, 20 years after two North Carolina railroads met there. Eventually, five rail spurs entered the small town. In this 1912 photograph, engineers check Engine 38 as passengers stretch their legs. In the distance at left is the Seaboard Air Line depot, a classic Victorian structure that today houses the National Railroad Museum and Hall of Fame.

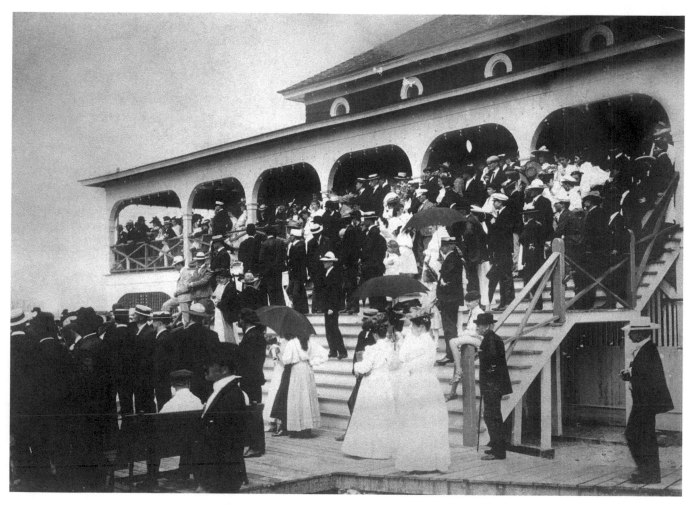

Well-dressed vacationers crowd the steps of Lumina Pavilion at Wrightsville Beach in 1912. Stars of the stage and the new movie industry, northern industrial magnates, and others from high society mingle with the local Carolina elite as they gaze toward the sea, possibly examining the pavilion's new giant movie screen.

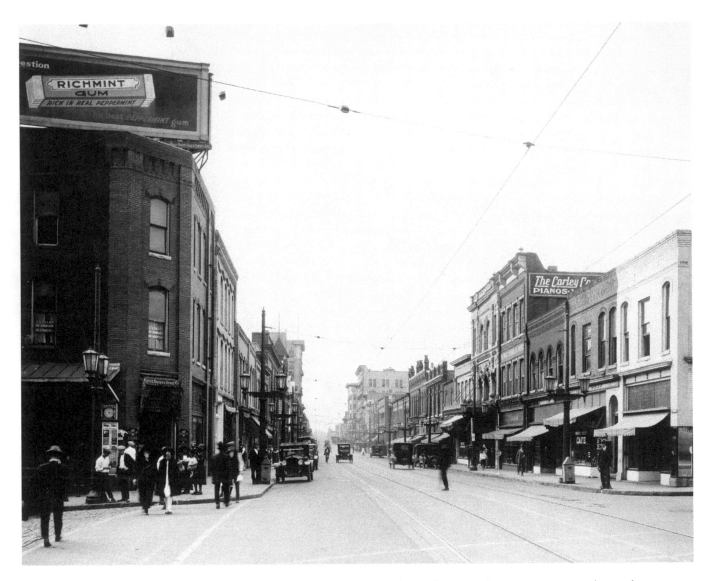

Downtown Durham in 1912 contrasts sharply with other images of North Carolina. Paved streets support cars better than buggies, cement sidewalks cover a city sewer system, and tracks carry electric trolleys. The downtowns of urban North Carolina seemed prosperous and progressive in the early 1900s—a prosperity usually based in tobacco manufacturing and the textiles industry.

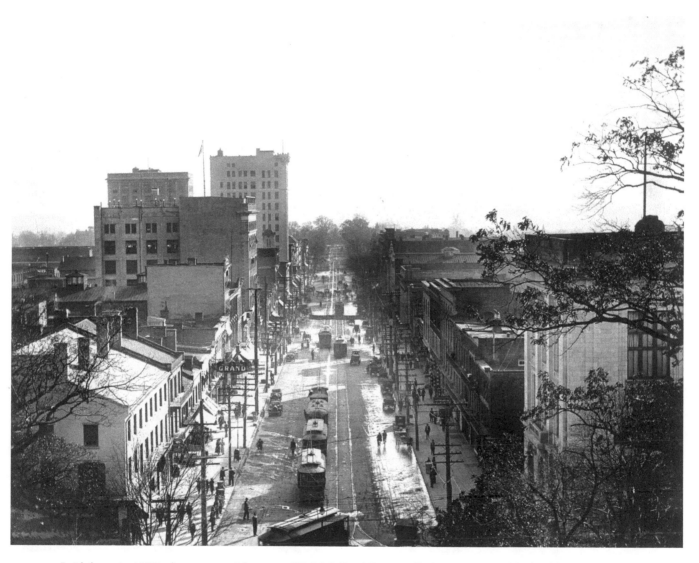

Laid down in 1792, the commercial center of Raleigh lined Fayetteville Street. Many of the buildings in this snowy scene from 1913 still survive—including the Briggs Building, seen halfway down the street at left. Built in 1874 to house the Briggs brothers' hardware enterprise, the four-story building was the tallest in eastern North Carolina for many years. Also surviving is the Masonic Temple, completed 1908 and seen just beyond the Briggs Building.

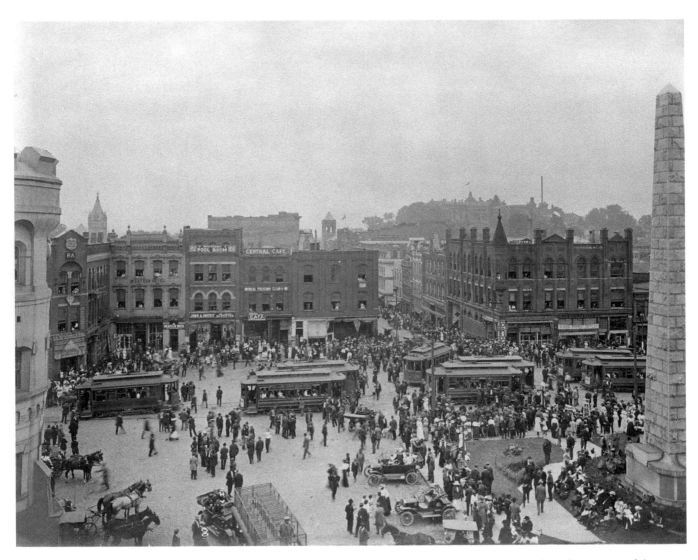

Asheville, sometimes called the Land of the Sky after the title of a book by Frances Fisher Tieran, was the urban center of the mountains by 1913. Cars, trolleys, and horses mix in this picture, but there can be little doubt that prosperity abounds in the city—a sharp contrast to rural regions of the Appalachians.

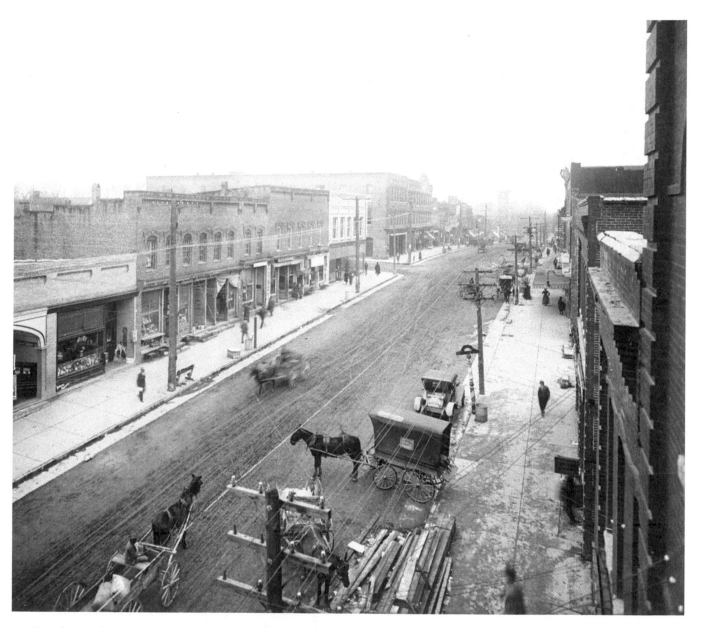

Even horses slip and slide along an unpaved Wilmington Street in Raleigh in 1915. World War I would delay the paving of the street, part of the business district for the state capital. In the early 1900s, the growth of infrastructure in Raleigh progressed at a slightly slower rate than in industrialized urban centers such as Winston-Salem, Durham, and Greensboro.

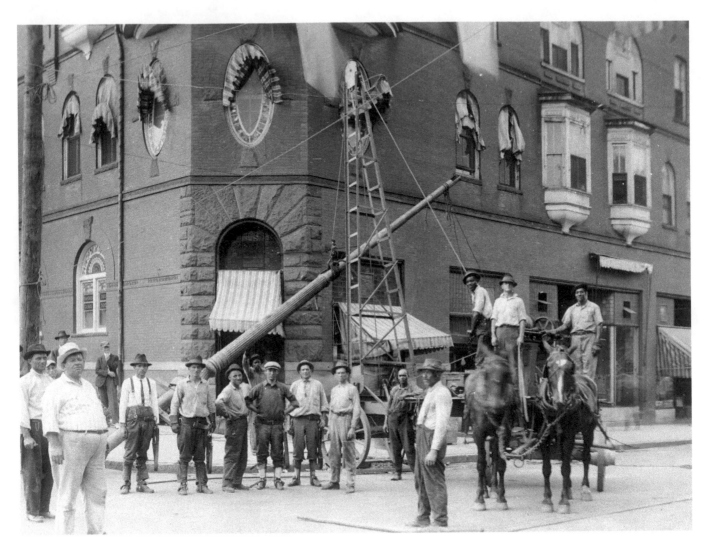

A line crew replaces old wooden poles at West Martin and McDowell streets in Raleigh in 1916. Apparently, when the power company needed dependable pulling power, they did not rely on electric or gas-powered trucks: they called on Old Dobbin. It is probable that the crew would become smaller the following year as the United States increased the size of its military upon entering World War I.

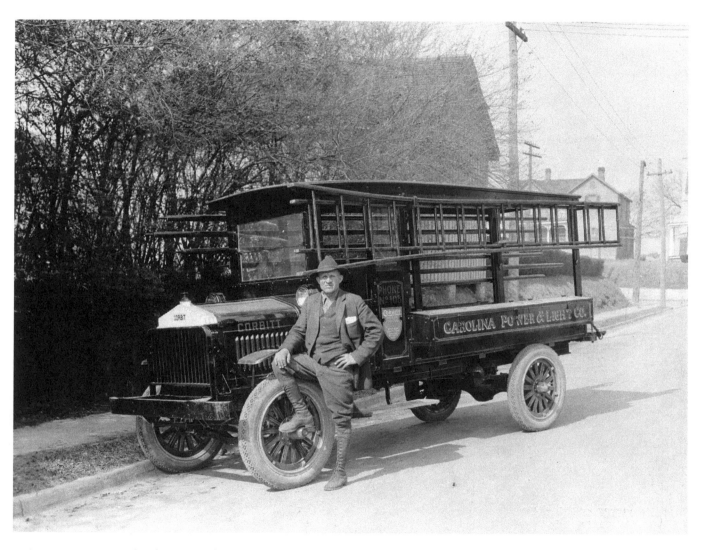

Area serviceman Frederick Fritz Daeke poses with his Carolina Power & Light truck in Henderson, Vance County, in 1918. The spread of electric power to rural North Carolina meant more trucks and more servicemen for companies providing electricity.

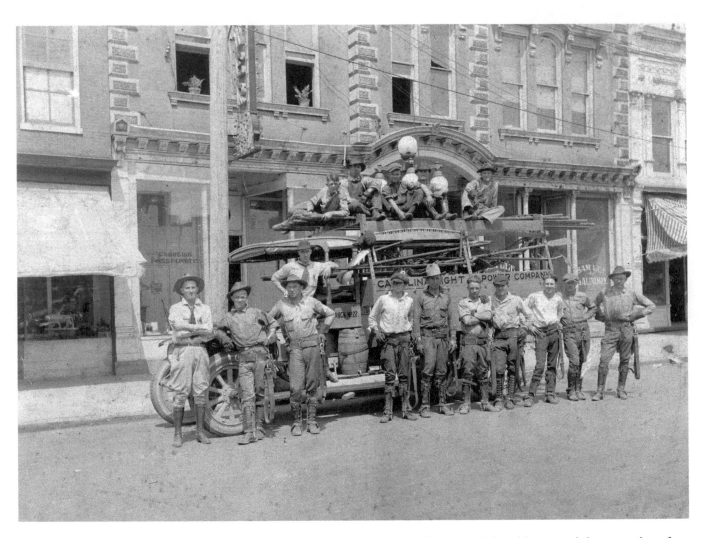

Linemen and crew pose with Carolina Power & Light's first two-ton White truck in 1919. The odds are good that a number of these crewmen had just returned from overseas after the end of World War I. With them, they brought new visions of the place of the Old North State in a much wider world.

TO AND THROUGH THE GREAT DEPRESSION

(1920–1939)

By the 1920s, hardware stores, such as McCrary-Redding Hardware in Asheboro, frequently replaced the old general stores of an earlier century, even carrying gasoline for automobiles and tractors. Before the hard years of the Great Depression, the credit extended by such stores kept many farmers in business until the tobacco market opened and the farmers could, at least partially, clear their debts.

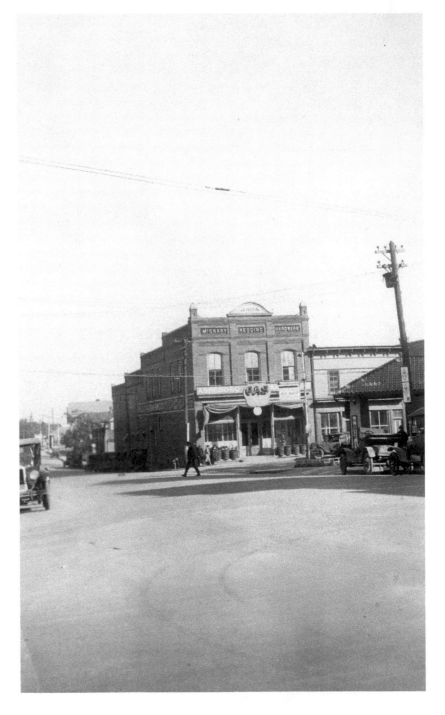

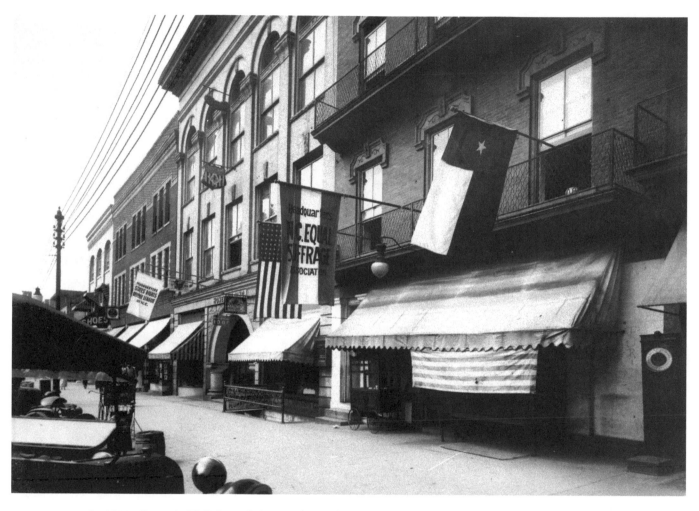

In 1913, Gertrude Weil formed the North Carolina Equal Suffrage League in Charlotte, reviving a failed movement from 1894. As women waited in the state headquarters in Raleigh in 1920, the General Assembly delayed ratifying the Nineteenth Amendment—in force nationally since June 1919—until 1921. Fearing the effect on laws which denied the ballot box to African-Americans, legislators then voted against women's suffrage.

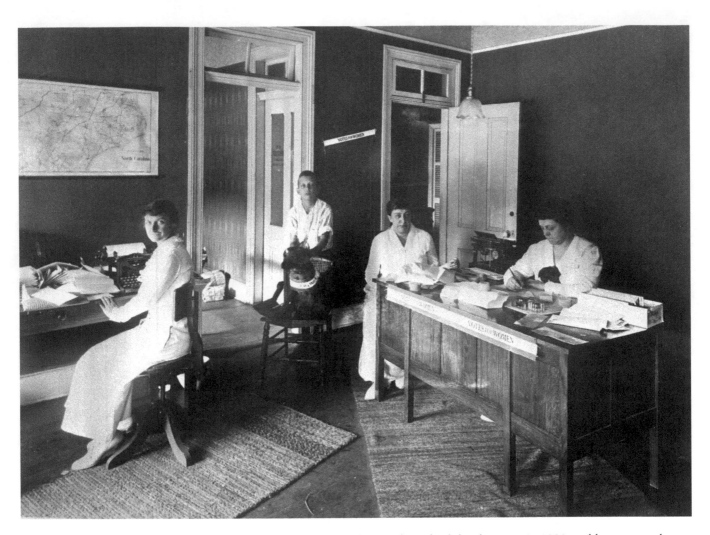

The hard work of suffragists such as Gertrude Weil, at left, and others in the Raleigh headquarters in 1920 could not persuade state legislators to pass the Nineteenth Amendment. Though the amendment became national law in 1919, it was not passed by the General Assembly until 1971.

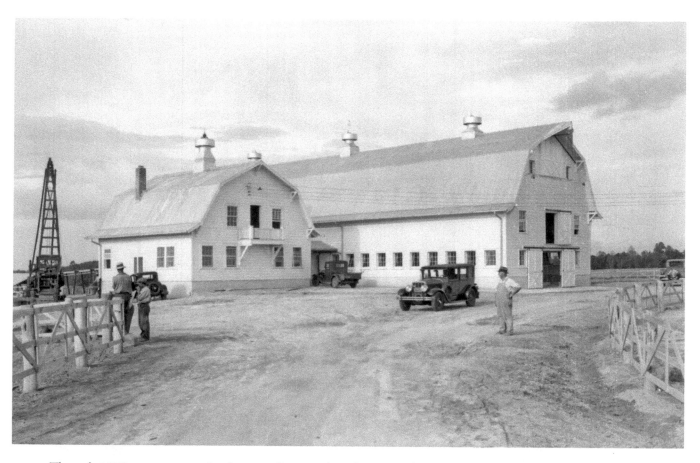

The early 1920s meant prosperity for many farms, such as this one in the Piedmont. Exports to European nations that were only slowly beginning to recover from the Great War, and increasing consumerism at home, meant top prices for produce and extended credit lines at banks. So farmers built new barns and purchased tractors and family vehicles—frequently on credit, and without considering the markets of the future.

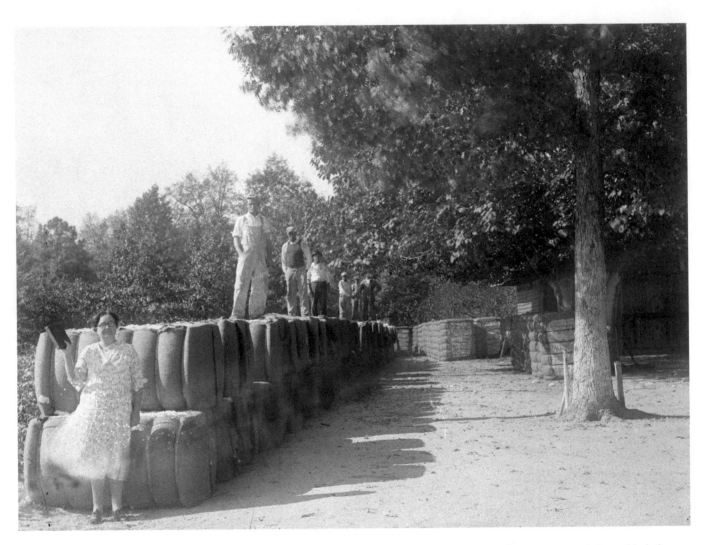

Small farms dotted the coastal plains in the 1920s. On this farm near Dunn, Harnett County, the cotton crop is in and baled, ready for market. Family members and hired help pose atop the bales, as the lady of the farm proudly displays her Bible. Farm families such as this one tended to be Protestant, Democratic, and very conservative.

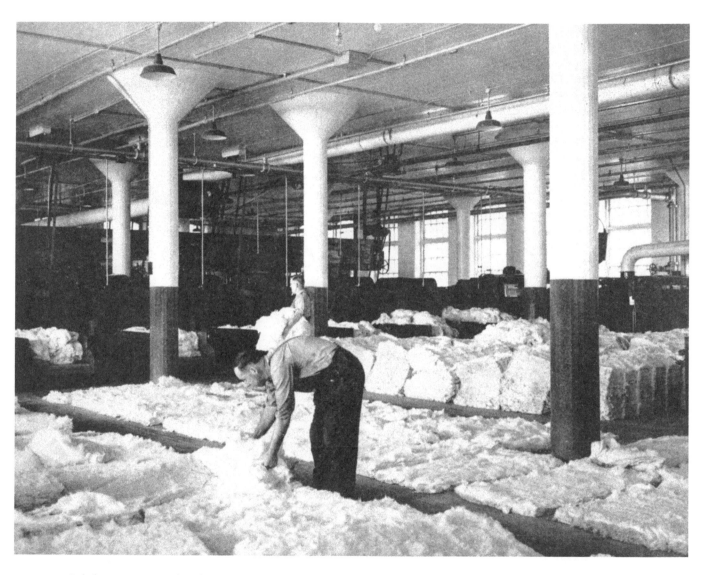

Baled cotton is sorted and prepared to wend its way through this North Carolina cotton mill around 1921. Without the protection of state and federal safety guidelines, working in a cotton mill was more than hard labor. Pervasive dust, repetitive heavy lifting, and moving equipment made the work dangerous.

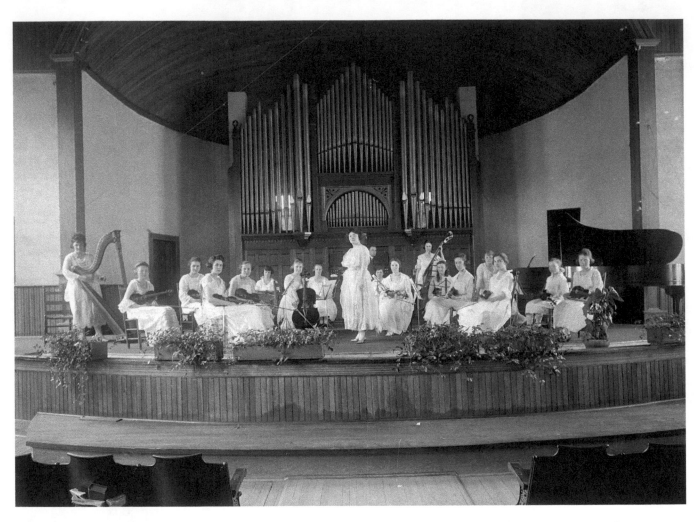

The Flora McDonald Orchestra of Flora McDonald College poses in the early 1920s. After graduating generations of female students, the institution merged with Presbyterian Junior College in 1958 to become St. Andrews Presbyterian College in Laurinburg.

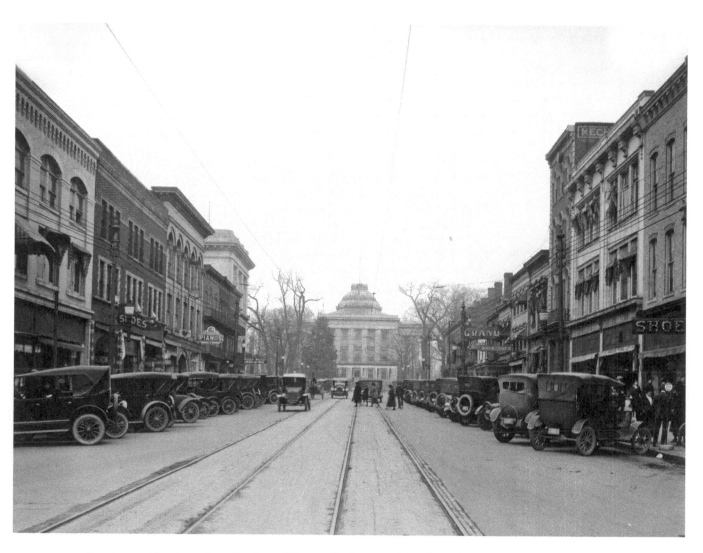

Despite a cold, wintry day, this view of Fayetteville Street and the Capitol in 1923 hints at prosperity and modernity in Raleigh. Cars, including new models, have replaced horse and buggy on the paved street. Business appears to be booming for local merchants.

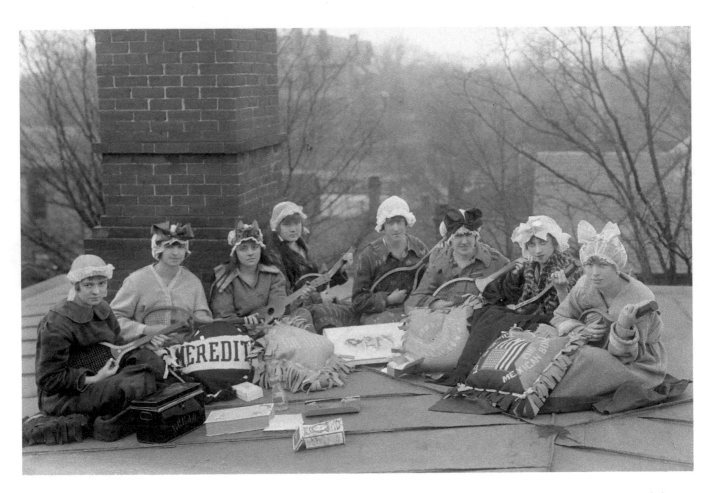

Students escape academics for an afternoon of casual fellowship and frivolity on a dormitory roof of Old Campus at Meredith College in the mid-1920s. Established as Baptist Female University in 1899, the institution became Meredith College in 1909. New Campus, six Georgian-style buildings including four dormitories, was completed in 1926.

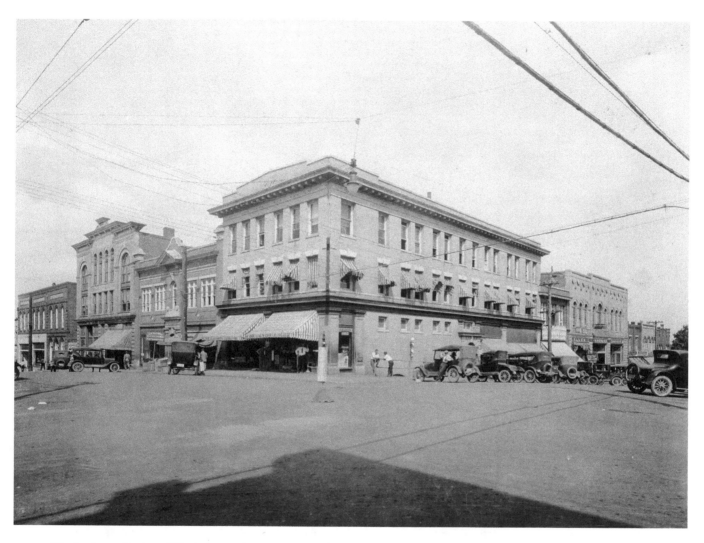

The business district of Wadesboro, the county seat of Anson County, has served its region since 1783. It is pictured here in October 1923 in a photograph taken from the vantage point of C. S. Wheeler Harness Shop—which still saw a great deal of business that year, since many local farms had not yet mechanized. However, the automobiles on the street hint that the days of harness shops, stables, and blacksmiths were numbered.

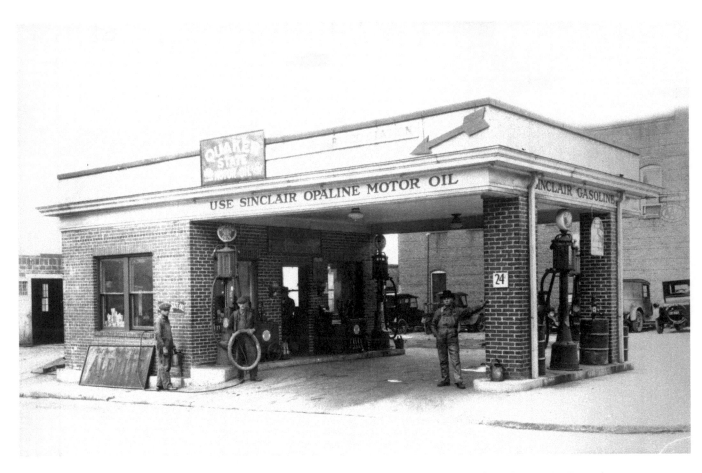

The advent of the automobile changed North Carolina in many ways. Service stations, such as this one in Greensboro in the 1920s, appeared on street corners in every town. Initially, those who owned cars did repairs themselves. As cars became common on Tar Heel roads and streets, however, specialists—automotive mechanics—arrived on the scene, and garages joined gas stations in growing numbers.

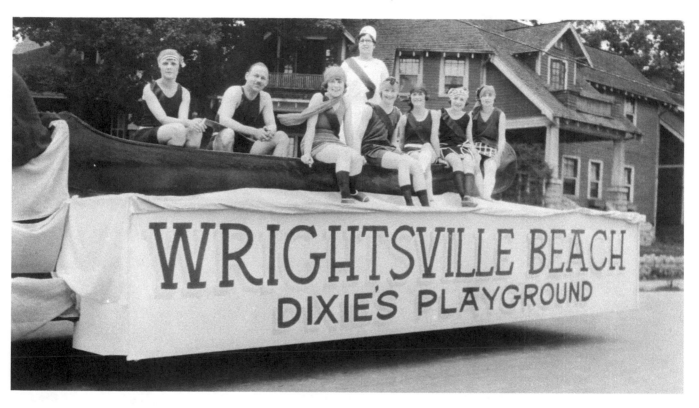

As the float in this parade in Wilmington in the mid-1920s proclaims, Wrightsville Beach remained a playground for the wealthy and locals alike, though many of the less wealthy preferred nearby Carolina Beach.

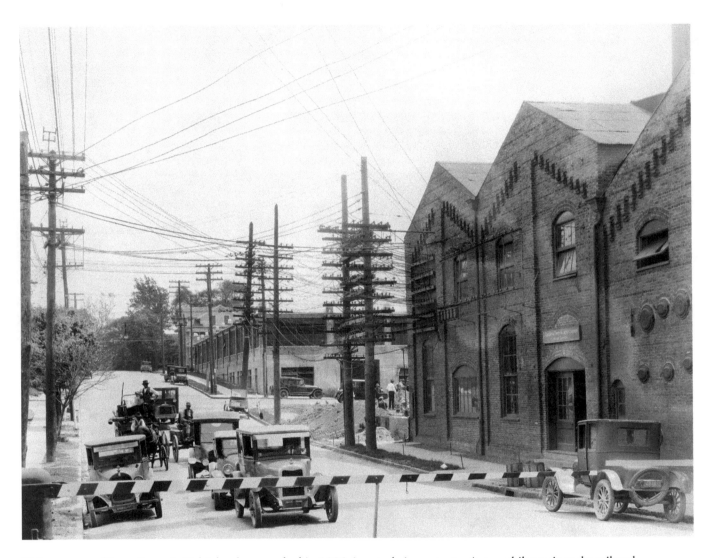

This segment of Jones Street in Raleigh, photographed in 1925, is a study in contrasts. Automobiles wait at the railroad crossing, but behind them are horse-drawn wagons. At the immediate right is the Raleigh Steam Plant, built in 1910 to meet the increasing demand for electricity in the city. The next building houses the streetcar garage. Both buildings still exist, but serve other purposes today.

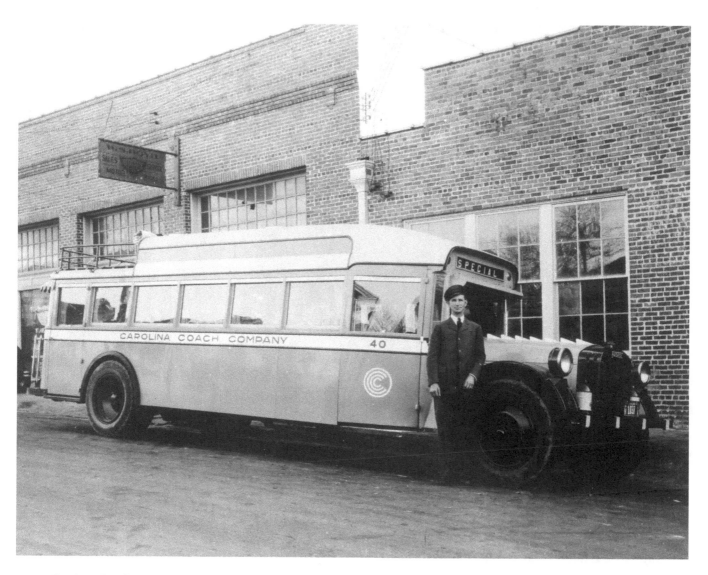

Carolina Coach Company began serving the city of Burlington and Alamance County in 1925 with 26 buses, some of them rather ramshackle. Over the years, the company prospered, as did many local bus companies. By the 1930s, local bus service was replacing electric streetcars throughout the state.

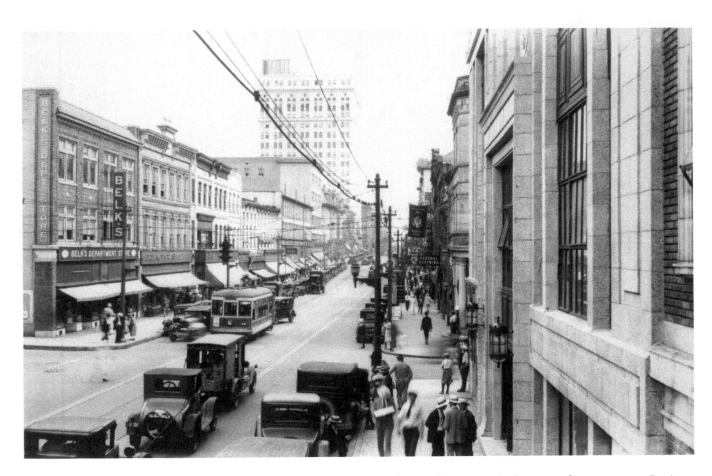

Downtown Greensboro in the 1920s is dominated by the Jefferson Standard Building, its only skyscraper for many years. During the early 1920s, as this image of a modern, bustling city reveals, Greensboro enjoyed an economic upturn.

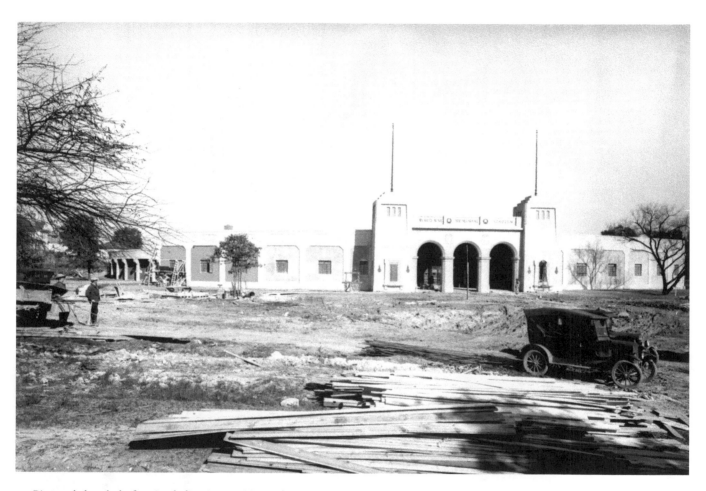

Pictured shortly before its dedication on November 11, 1926, War Memorial Stadium in Greensboro honored North Carolina's veterans of the Great War. Designed for football, the stadium hosted minor league baseball from the 1930s until 2004 and served as the baseball and football venue for local colleges and amateur events.

Segregation meant separate business districts in North Carolina towns. Hargett Street was central to the African-American community of Raleigh in 1926, both as a business district and for social gatherings.

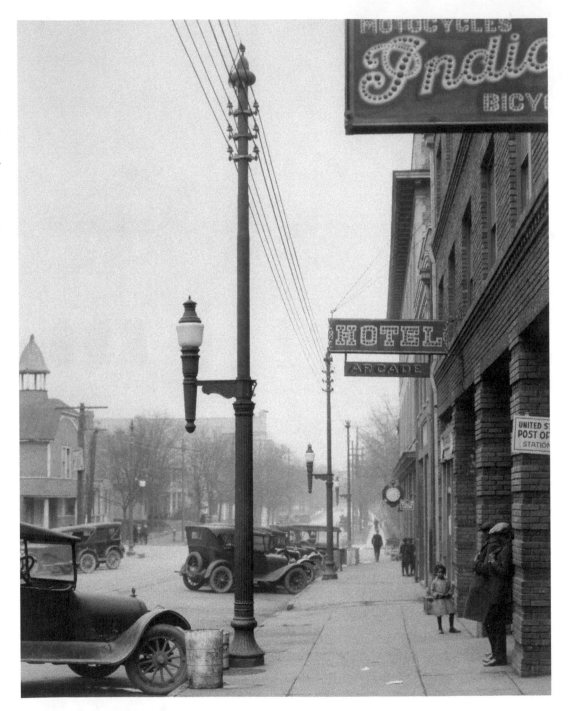

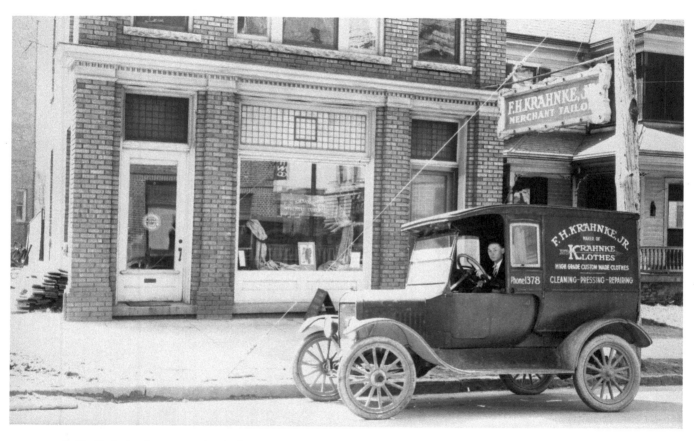

F. H. Krahnke, Jr., operated a clothing store in Greensboro in the 1920s and 1930s. Located on West Market Street near Courthouse Square, the business offered cleaning and repair services, in addition to tailoring. The store's delivery truck, seen here in the mid-1920s outside the shop, was a familiar sight around town.

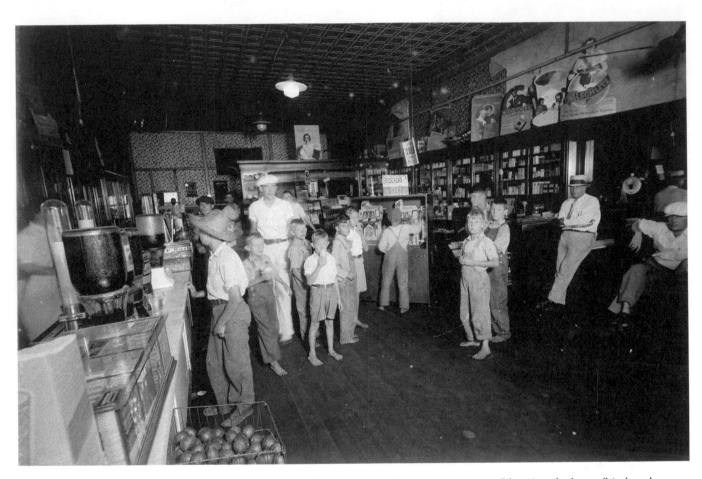

Kids enjoy ice cream and sodas at a drugstore in Harnett County, no doubt interrupting men "shooting the breeze" in booths out of view, on a hot Carolina afternoon in the 1920s. In those days before cell phones and the Internet, corner drugstores and soda shops were the places to meet others and enjoy a soft drink while exchanging local gossip.

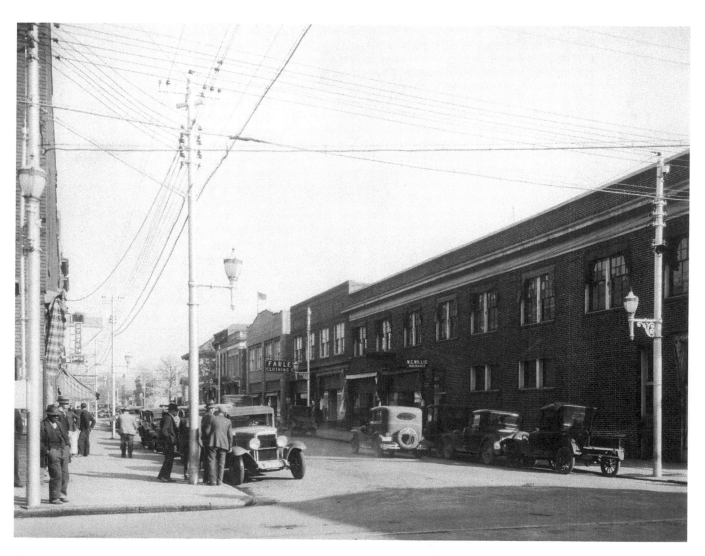

Having grown from a single hotel, built at the intersection of the old New Bern Road and the Wilmington & Gaston Railroad, to a small town, Goldsboro became the county seat of Wayne County in 1847. On the strength of agriculture, the town prospered, as revealed by this photograph from 1928 of North John and Walnut streets.

Constructed of steel and concrete at the corner of Elm and Market streets, the Jefferson Standard Building dominated the Greensboro skyline for several decades. Completed in 1923, the 17-story, U-shaped corporate office of Jefferson Standard Life Insurance remained the tallest building in North Carolina until 1929.

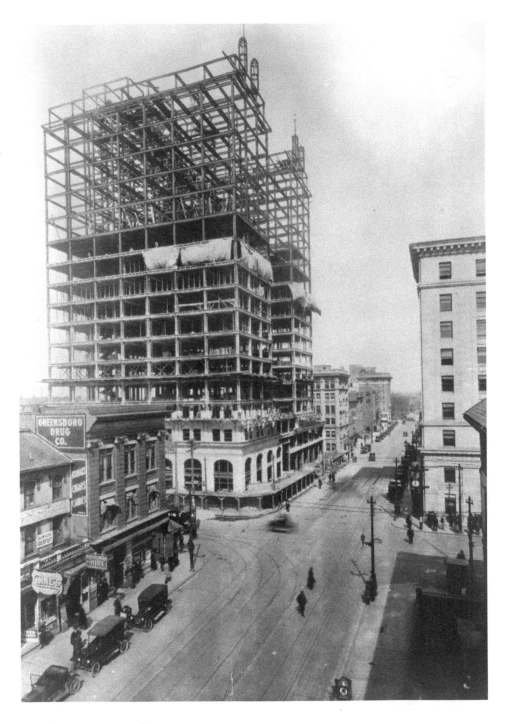

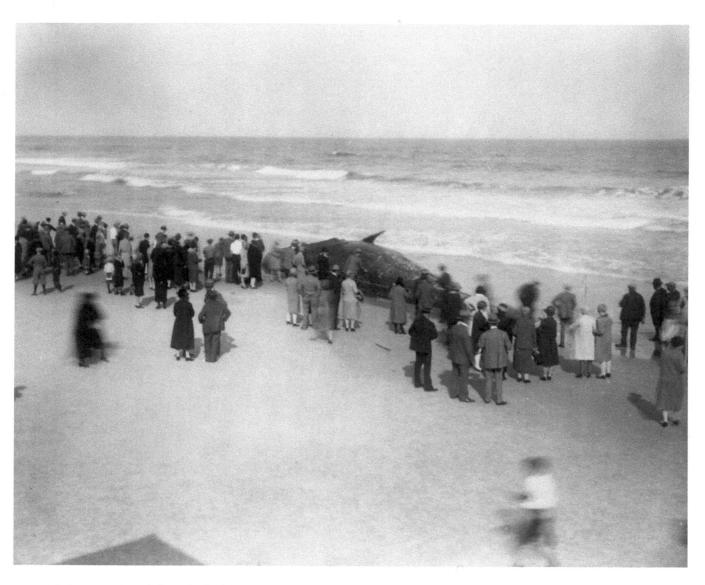

A 55-ton sperm whale washed ashore at Wrightsville Beach in 1928. Tourists flocked to see it—until the smell reached epic proportions. Eventually, the rotting carcass made its way to the North Carolina Museum of Natural History in Raleigh where its skeleton, nicknamed "Trouble," inspired the museum's logo.

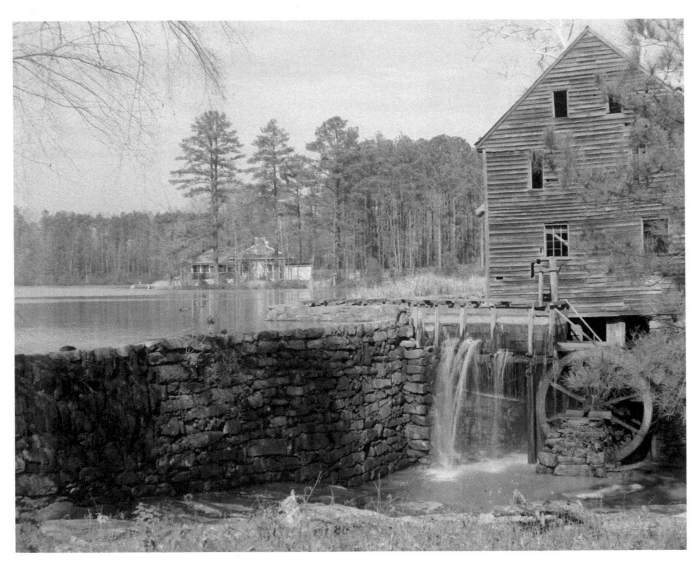

Built around 1756, one of the last surviving water-powered grist mills in North Carolina stands at Yates Pond near Raleigh. In the 1920s, the mill retained both the original dam and waterwheel, but both were swept away by flooding from Hurricane Fran in 1996. Restored, the site is now a museum and park.

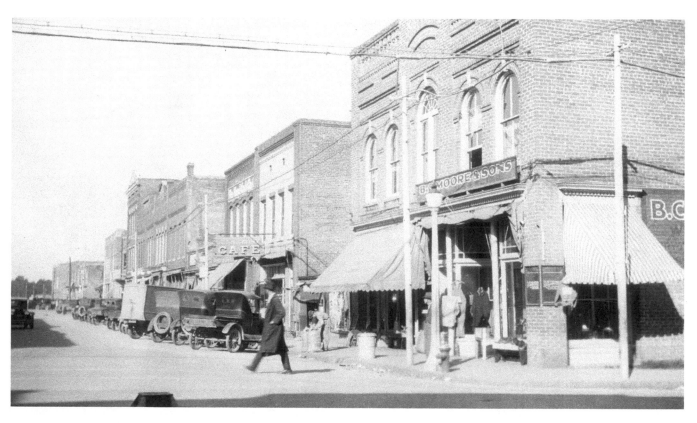

Incorporated in 1796, Asheboro was named for Governor Samuel Ashe. The county seat of Randolph County, it prospered in the early 1920s. By 1930, as the Great Depression deepened, times became harder—the young man at center seems to be ransacking a pair of trash cans.

The mayor and assorted civilian and military dignitaries observe the Armistice Day Parade in Greensboro in 1930. The depression already beginning to grip the city and state would end only when victory in World War II helped jump-start the American economy.

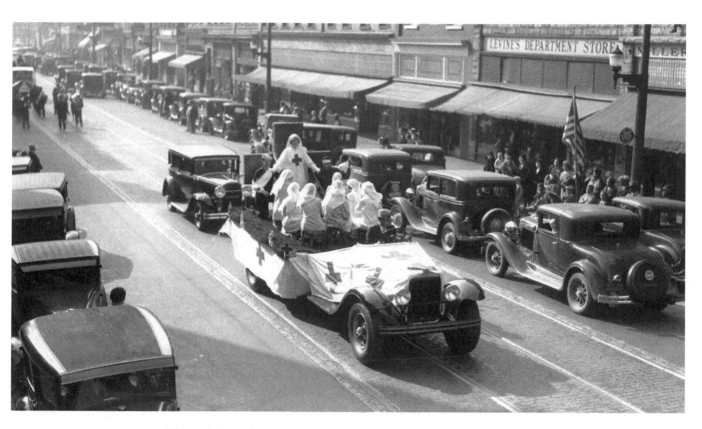

The Red Cross float in Greensboro's Thanksgiving Parade of 1931 passes Levine's Department Store.

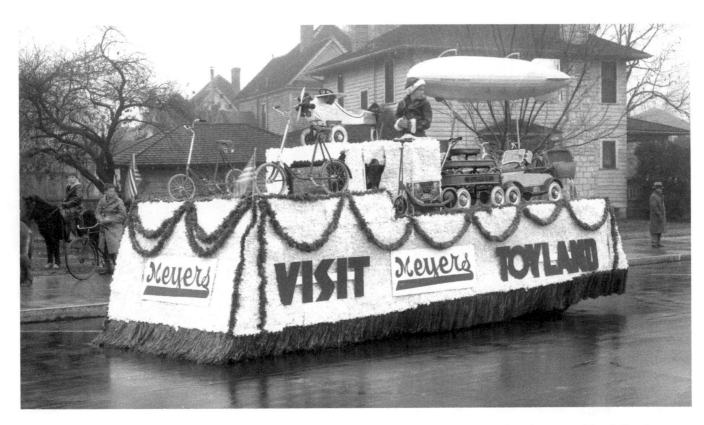

The Thanksgiving Parade in Greensboro in 1931 seems not to have been heavily attended, perhaps because of the chill, rainy day. Or perhaps too many parents found a float such as that of Meyers Department Store to be depressing—who could afford expensive toys for their children?

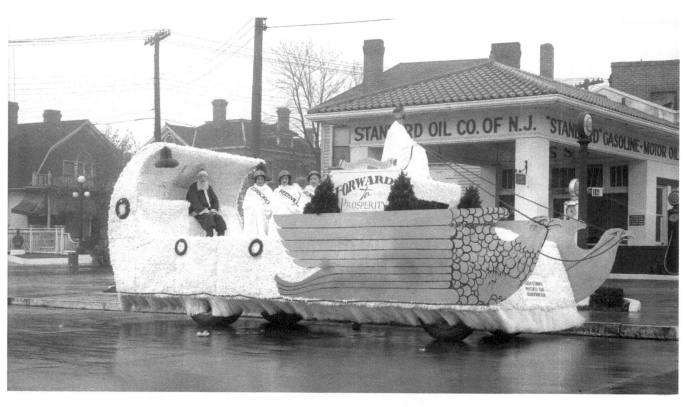

Santa's float carried the wishes of everyone in Greensboro in 1931: "Forward to Prosperity." Unfortunately, prosperity was some years away. The following month, Greensboro experienced its first bank closure of the Great Depression.

Stein's Clothing Store, on the corner of Elm and Market streets in Greensboro in the 1930s, is typical of the stores that eventually drove such tailors as F. H. Krahnke, Jr., from the business (or into a more exclusive market, at least). Tailors simply could not compete with the mass-produced and off-the-shelf clothing the textile industry offered to distributors. Most textile operations survived the Great Depression, particularly those that produced low-cost items such as blue jeans.

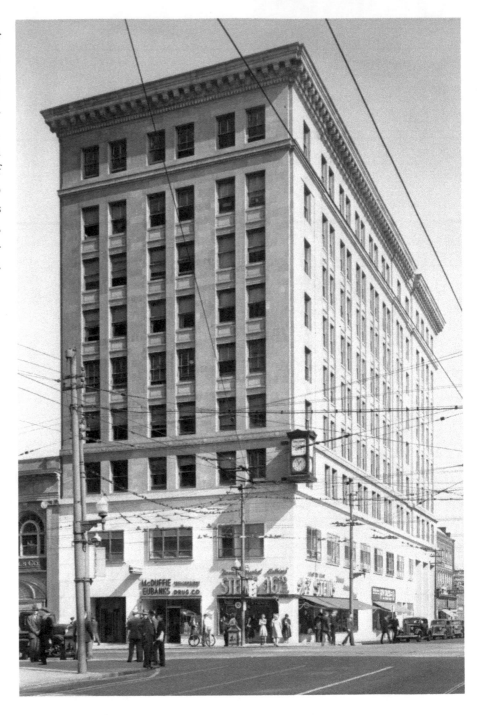

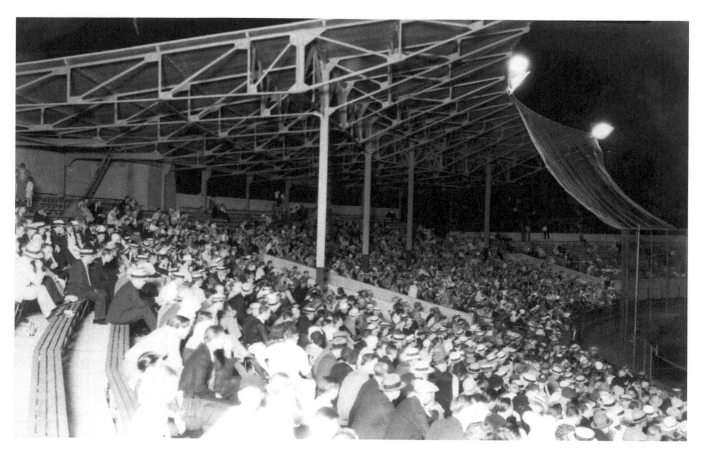

The need for cheap entertainment during the 1930s led to strong followings for local baseball teams and strong attendance at their games, such as this night game in Greensboro.

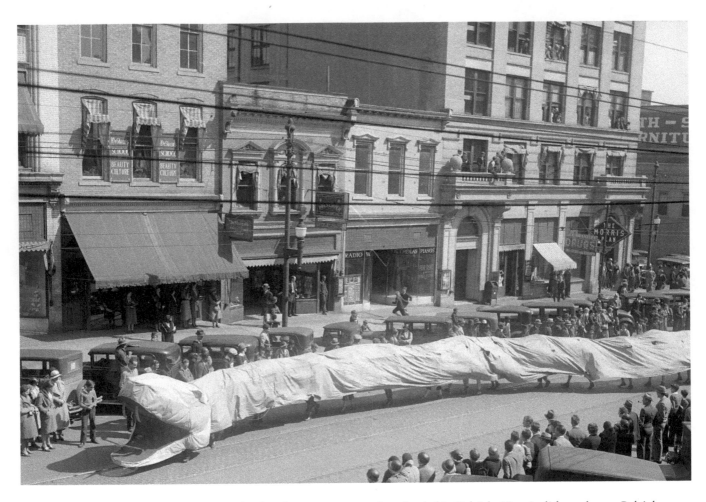

When St. Patrick drove the snakes from Ireland, at least one seems to have landed in Raleigh. Here it slithers along a Raleigh street during North Carolina State College's "St. Patrick's Brawl Parade" in 1932.

Officers and a city official wait for the start of Greensboro's Armistice Day Parade in 1932.

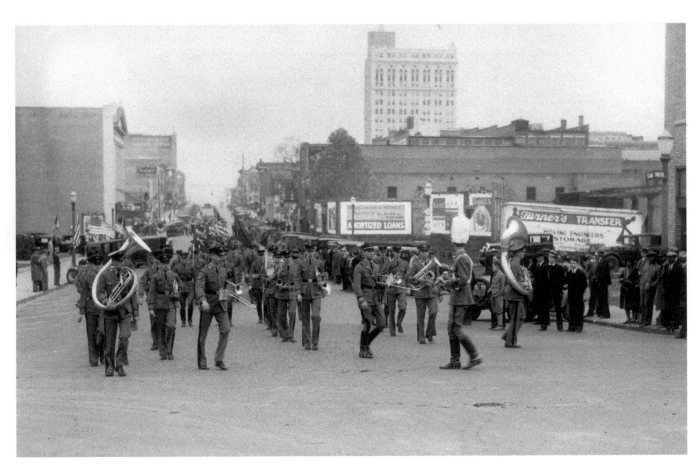

A band leads the parade on Armistice Day in 1932 in Greensboro.

For North Carolina, the darkest days of the depression fell in 1933-34. Farm income had dropped by almost 66 percent while continued cuts cost state employees 45 to 60 percent of their pre-depression pay. But these were the lucky ones—they had some income where many did not. In Henderson, Vance County, a quiet Garnett Street on an early evening in 1934 seems to reflect the somber, fearful mood of many Tar Heels.

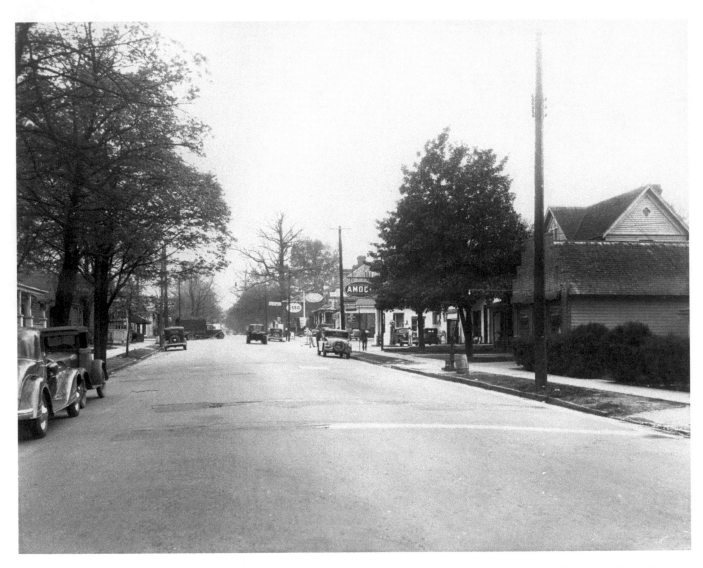

Traffic is light near the Amoco and Esso service stations in the 600 block of North Person Street in Raleigh in 1935. Gas prices averaged 17 cents a gallon in 1935, but who had 17 cents to spend on gas?

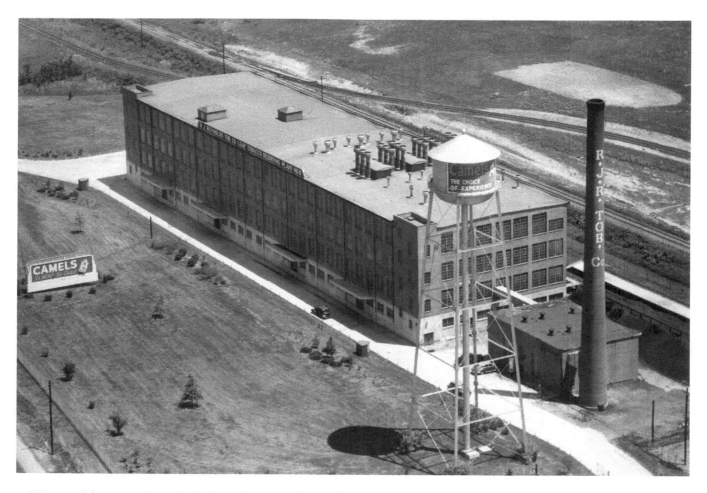

Winston-Salem came through the Great Depression better than most cities in North Carolina, primarily because of tobacco and textiles manufacturing. Both industries continued operations during the 1930s, and R. J. Reynolds even expanded its holdings; the firm's Leaf Redrying Plant No. 8 is pictured here in the late 1930s. In 1935, the Federal Reserve Board rated Winston-Salem among the top 10 cities in the nation in industrial output.

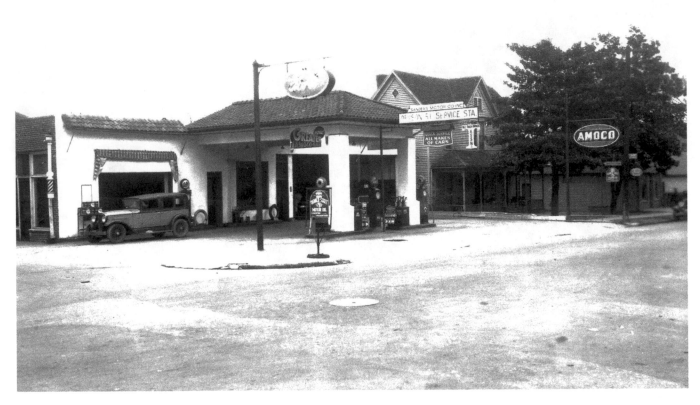

A service station on North Person Street in Raleigh, despite its claim to provide "quick service" to "all makes of cars," sees little business on this day in 1935.

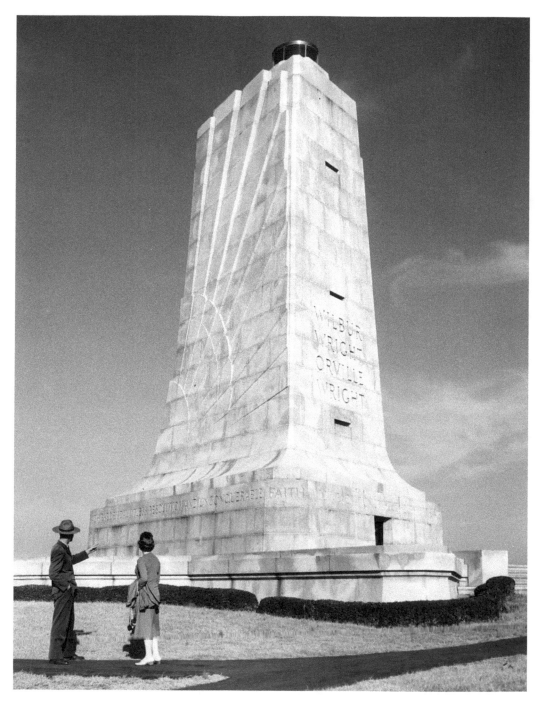

Dedicated in 1932 and seen here three years later, the Wright Brothers Memorial at Kill Devil Hills bears an inscription around the base that reads, "In commemoration of the conquest of the air by the brothers Wilbur and Orville Wright / Conceived by genius / Achieved by dauntless resolution and unconquerable faith."

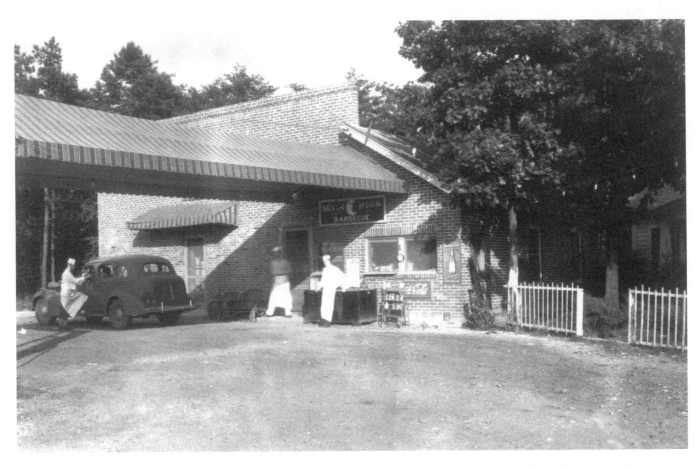

The Old North State has a reputation for fine barbecue, though the eating establishments may not always be four-star. In Greensboro in 1937, the locals may have steered visitors to the Silver Moon Barbecue Restaurant. Unfortunately, no one seems to remember if they used vinegar-based or tomato-based sauce.

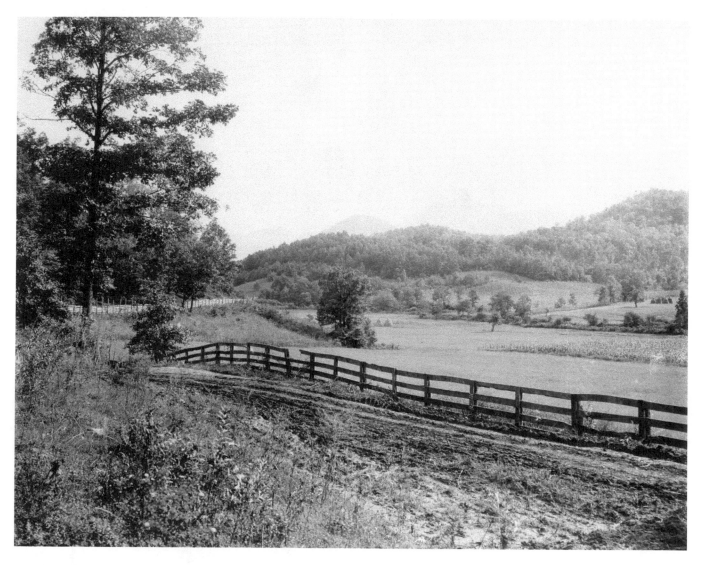

Rolling farmland and forests combine to form a lovely pastoral scene in Jackson County in the late 1930s. One hopes the owner managed to avoid foreclosure during the Great Depression.

The Piedmont is known for its pottery. In 1934, A. R. Cole relocated his family to Sanford, Lee County, from Seagrove, Randolph County, where he continued the pottery business his family had practiced as far back as the seventeenth century in England. Today, his family still turns red Carolina clay into lovely pottery.

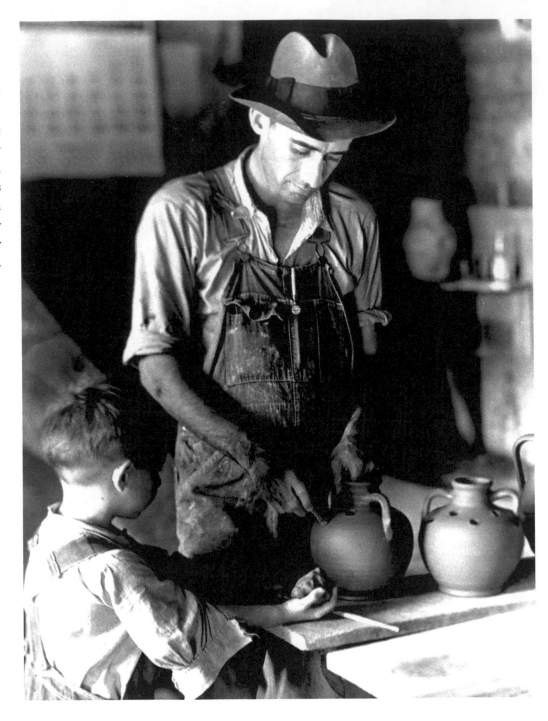

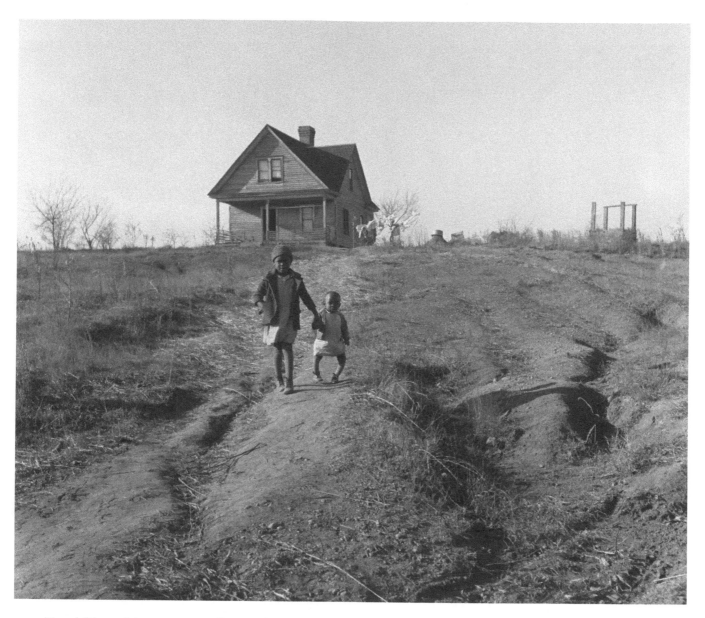

Two children of sharecroppers walk across badly eroded farmland near Wadesboro in December 1938. The Great Depression caused suffering for many North Carolinians, but few suffered as much from abject poverty as the many families subsisting as sharecroppers.

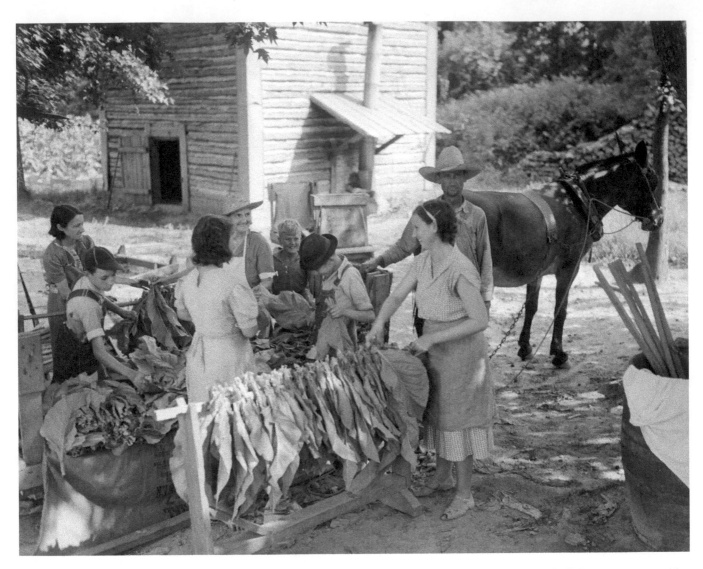

Smiling women tie tobacco on a farm near Wilson in 1938. Before the days of automatic harvesters and bulk barns, crews would "crop" the ripe leaves and place them in "drags." Mules hauled full drags to the barn, where children would neatly bundle the leaves and "hand" them to the "tie-ers," who would then "loop" or "tie" the bundles to the tobacco stick. Full sticks were "hung" in the barn for curing. Gossip and singing frequently marked activity at the barn—as opposed to the stooping and sweating endured in the field.

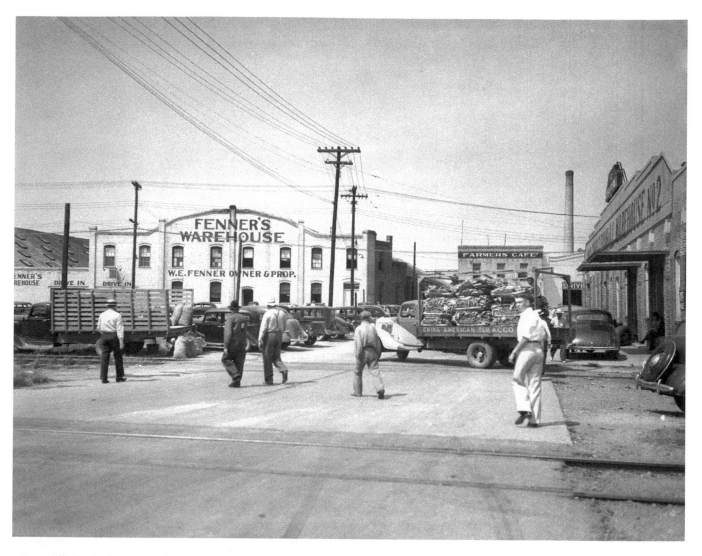

A truckload of tobacco purchased by China-American Tobacco Company leaves a Rocky Mount warehouse in 1938. These leaves were ultimately destined for consumers in Japan and China. Inside the warehouses, the auctions continued as farmers waited to collect their checks before stopping at Farmers Café for coffee.

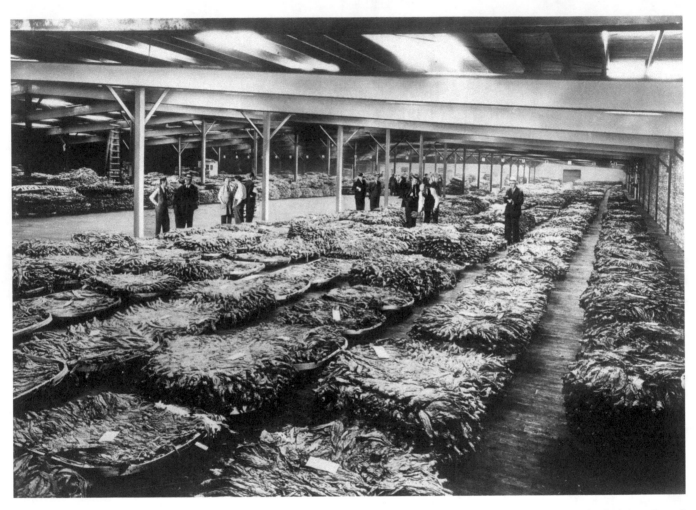

Tobacco lines the floor of a warehouse in Wilson in 1938, awaiting the auctioneer's distinctive chant as buyers check the quality of the leaves. Their bidding would determine the future for the region's farmers, and in 1938 the market was the best per pound that farmers had seen in years.

Construction on the Blue Ridge Parkway began in late 1935 as part of President Franklin Delano Roosevelt's effort to funnel federal revenue into jobs for Americans during the Great Depression. Work continued until the final dedication in 1987, though parts of the parkway had been in use for decades. This picture of the work in progress dates to August 1939.

This peaceful scene of a boat and drying nets at Gillikin Island in Onslow County in 1939 has little to do with tourism and lots to do with economics. Fishing remained a critical industry in North Carolina during the Great Depression, providing revenue to the fishermen and protein to the state's citizens.

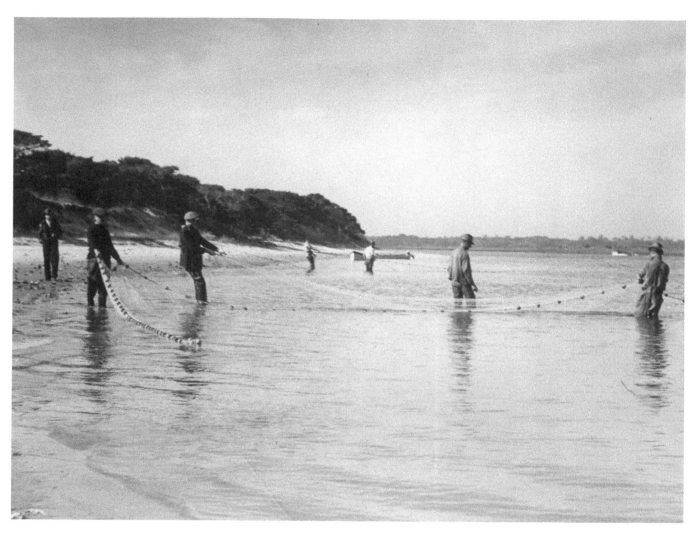

Fishermen pull their net through the water off Gillikin Island in Onslow County in 1939. The labor was backbreaking, but by that year the profits were improving.

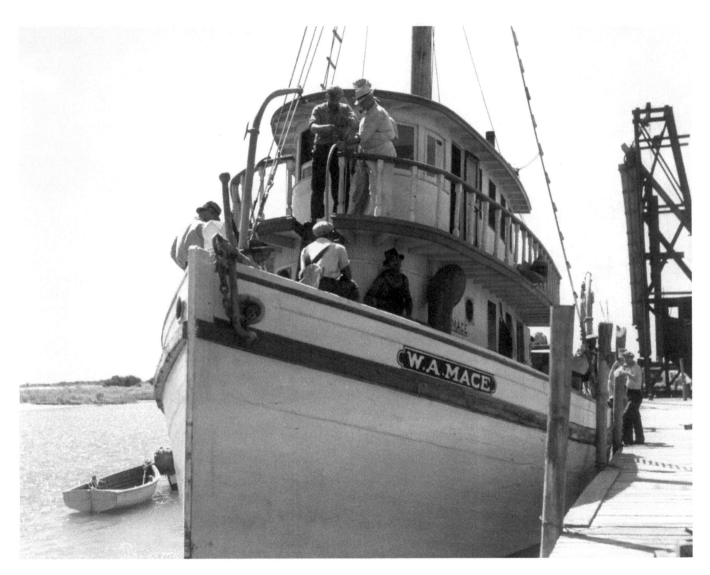

The *W. A. Mace* prepares to leave port in search of menhaden in 1939. The largest concentration of Atlantic menhaden, a baitfish and the primary source of fish meal in the United States, can be found in the sounds and coastal waters of North Carolina. Today, much concern exists about overfishing—such was not the case in 1939.

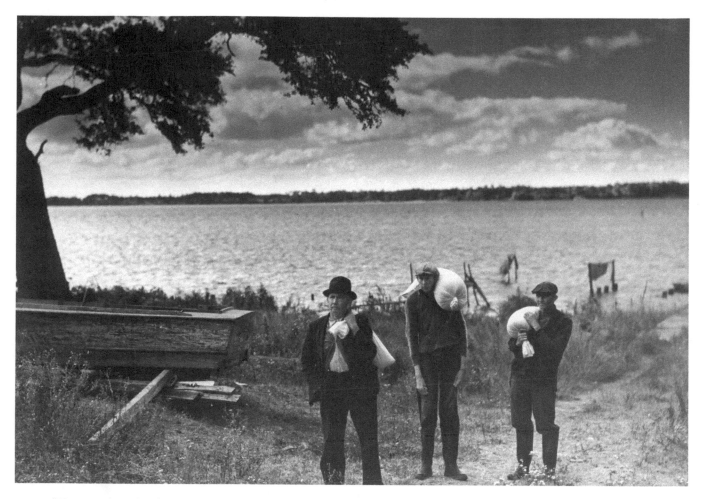

"Home is the sailor, home from the sea." These gentlemen are home from a hard day of fishing in Onslow County in 1939.

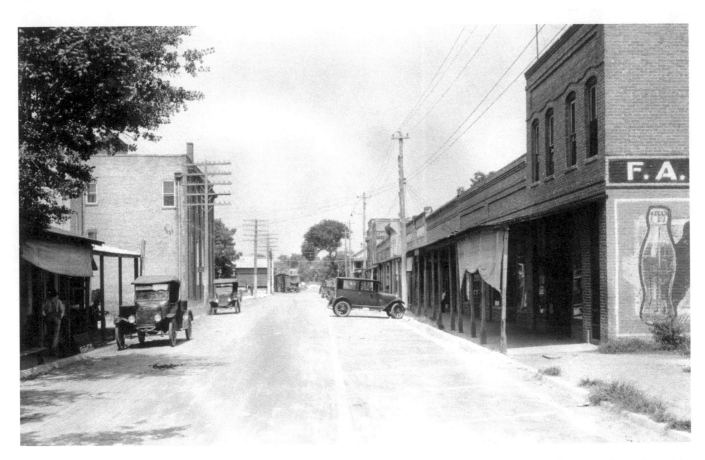

In 1939, Main Street in Jacksonville reflected the ravages of the Great Depression. That would begin to change in September 1941 with the establishment of Camp Lejeune by the First Marine Division.

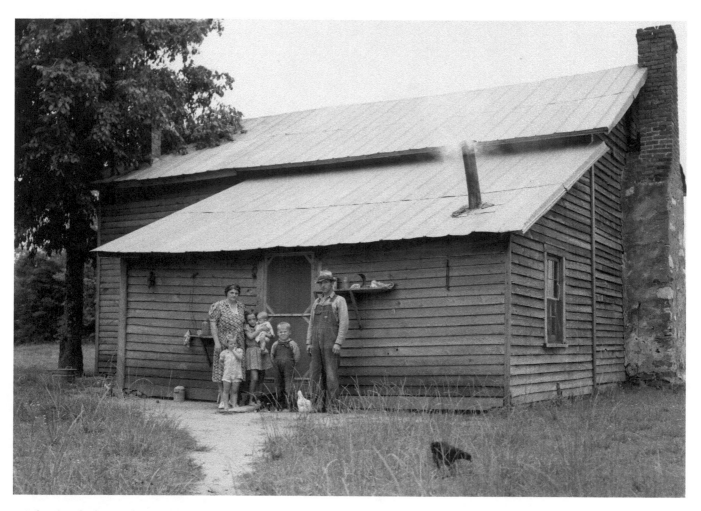

A family of tobacco sharecroppers stand outside their house in Person County in July 1939. By August or September, they would have received their share of the money for the crop they had planted, tended, and harvested for the landowner. With luck, there would be enough money to see them through the coming winter—but it would never be enough to see them completely free of debt. They and others in the region were photographed that July by Dorothea Lange of the Farm Security Administration.

Talking and visiting are as important as shopping on Main Street in Pittsboro, Chatham County, in July 1939. It has been said that the Great Depression made people pull together— but in North Carolina, segregation remained both law and custom.

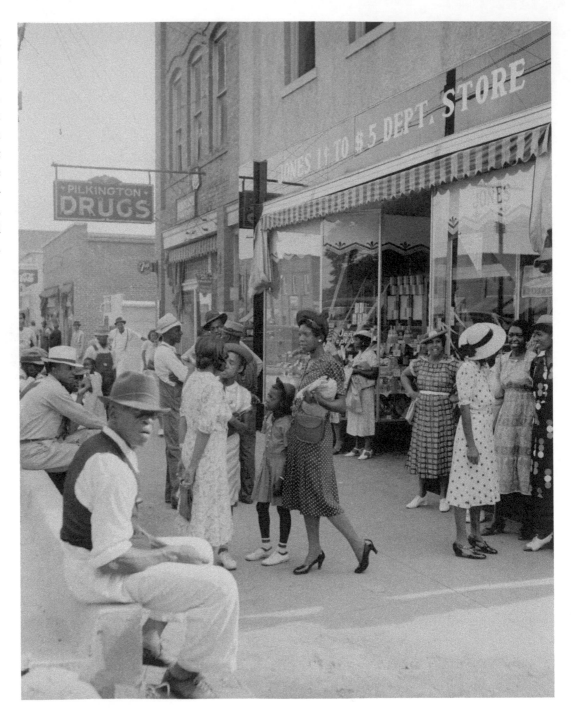

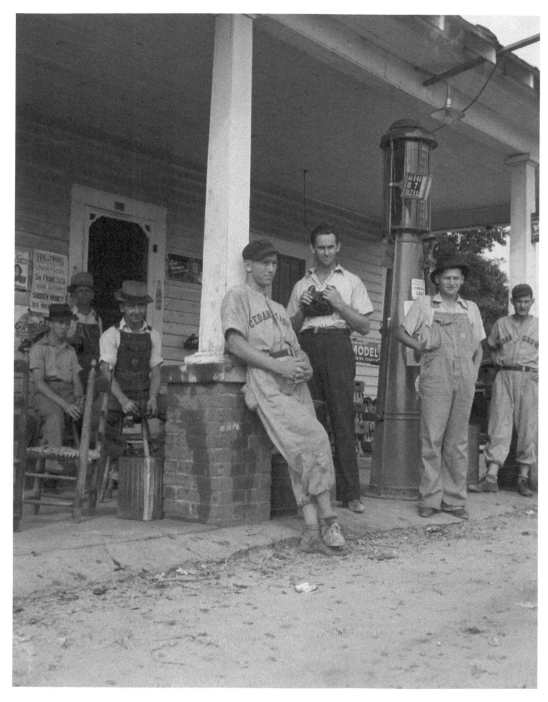

As filling stations replaced country stores, they became rural gathering places. Farmers would stop to play a game or two of checkers while shooting the breeze and perhaps drinking a Royal Crown Cola, and the local baseball team would gather there before heading to their big game—just as this team from Cedar Grove, Orange County, did on July 4, 1939.

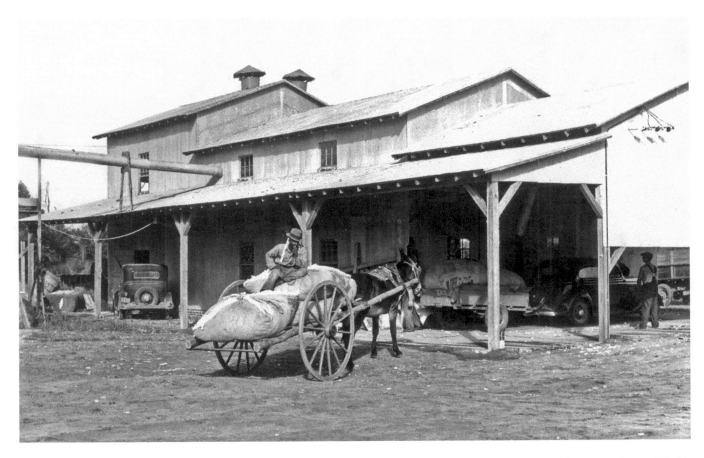

A farmer waits to sell his cotton at a cotton gin in Richlands in 1939. Though the market for cotton would improve during World War II, little could help the poorest of the independent or tenant farmers, who still scratched out a living with mule and plow from a few acres of overcultivated land. They simply could not acquire the capital to expand beyond subsistence-level farming.

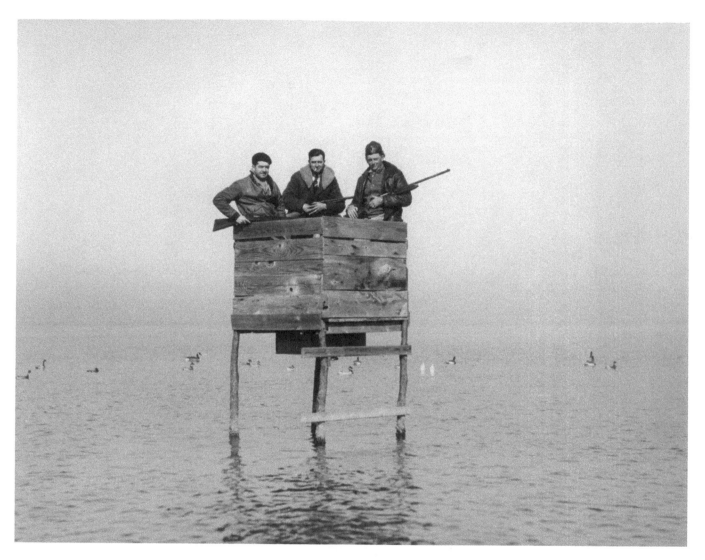

Decoys float on the water of Core Sound as three hunters wait for ducks to land, around 1939. North Carolina has long been famous for its wildlife, and lodges dedicated to hunting proliferated in the first three decades of the twentieth century.

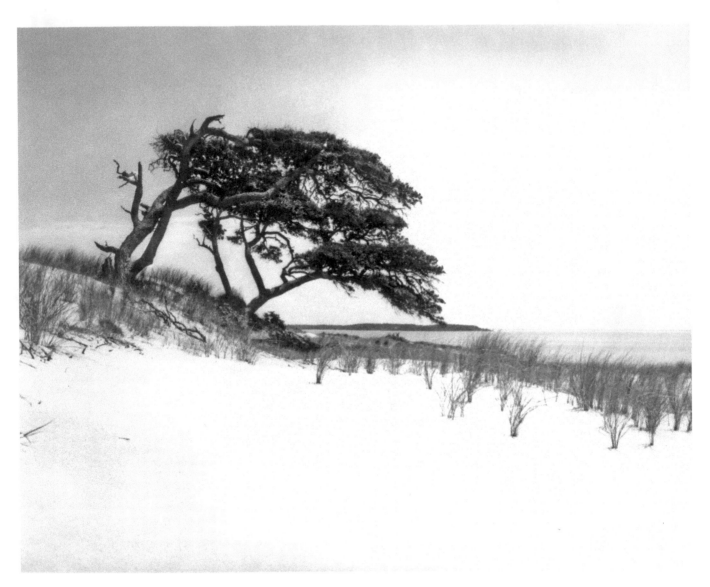

Once there was a desolate beauty to be found along most of the Carolina coast, such as at Duck in 1939. Today, one seldom finds such a place. But in 1939, as unemployment nationwide remained depressingly high, few North Carolinians would have hesitated to trade beauty, desolate or not, for progress and economic security.

THE WAR AND GROWTH

(1940–1950s)

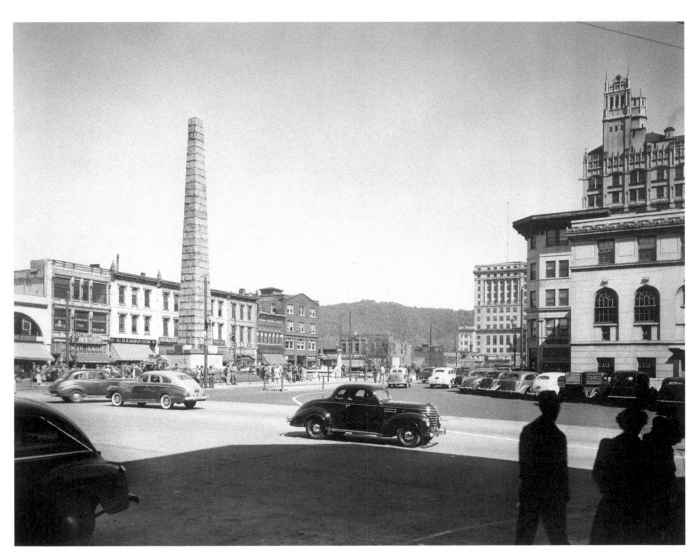

By 1940, Asheville revealed little of the ravages of the Great Depression, but they were there in the form of debt that would not be completely paid until 1977. The Buncombe County Courthouse, completed in 1928 at a cost of $2 million, is at center-right. The obelisk at left is a memorial to Confederate governor Zebulon B. Vance, who practiced law in Asheville.

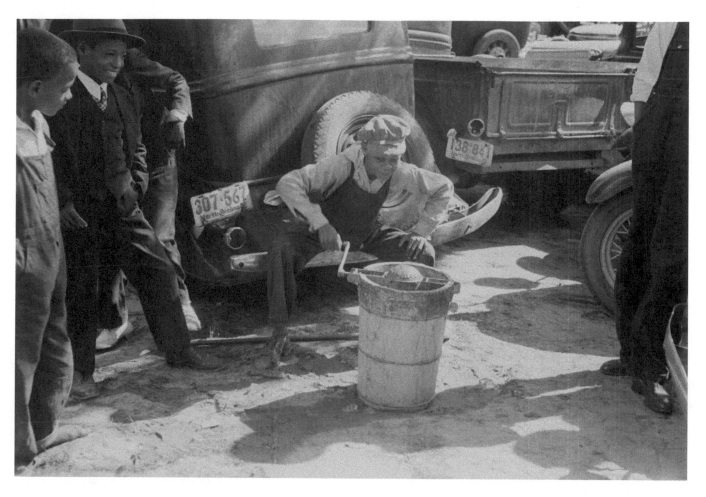

How many remember turning the handle of an ice-cream maker? Toss in the ingredients, add the ice and rock salt, turn that handle again and again until the tasty treat, frequently flavored with local fruits, is ready. However, in October 1940, this young man was working for a cause. The ice cream was to be sold for the benefit of his church near Yanceyville in Caswell County.

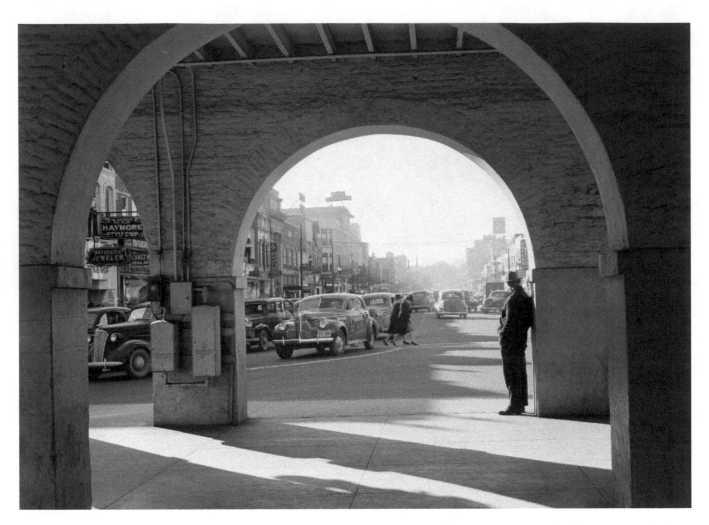

A man views the traffic on Main Street in Fayetteville, Cumberland County, around 5:00 P.M. on a March afternoon in 1941 from the vantage point of the Old Market House. The artillery-training grounds at nearby Fort Bragg had swollen with trainees as war threatened, resulting in both heavy traffic and a booming local economy.

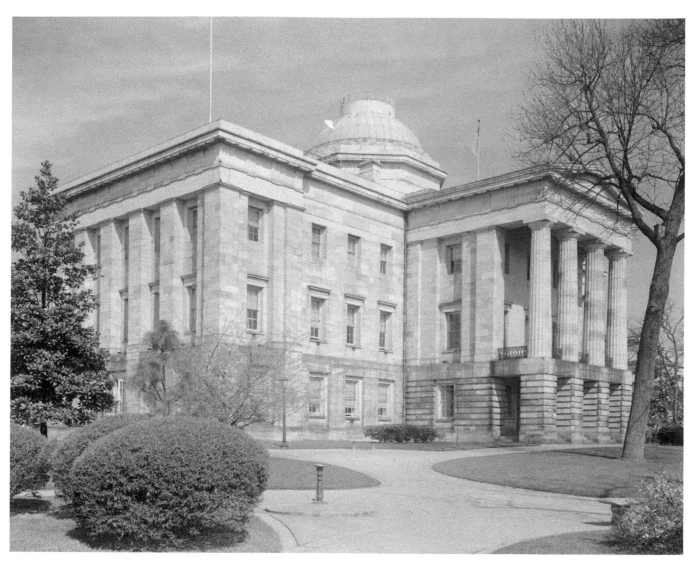

The State Capitol in Raleigh seems somnolent in this view from the southeast in the early 1940s. Such was not the case on most days, as North Carolina joined the nation in preparing for a long war. U-boats threatened the coast, the loss of manpower to the military left gaps in factory workforces, and resources had to be marshaled for a frequently desperate and invariably vicious conflict.

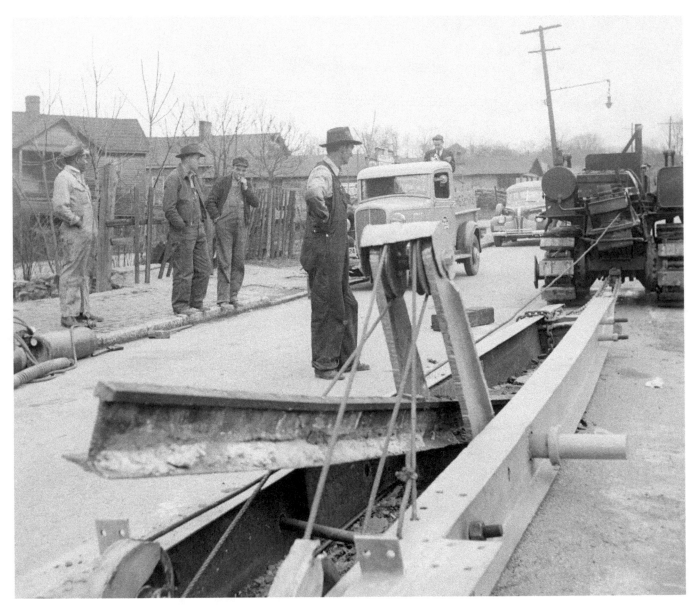

Rationing and recycling became watchwords during the war years. Local rationing boards issued coupons for items in short supply such as gas, rubber, sugar, and coffee. The North Carolina Salvage Committee headed scrap drives, occasionally discovering treasure troves of recyclables such as trolley tracks, buried by most cities when they shifted to bus service in the 1930s. Here, tracks are salvaged in Asheville in May 1942.

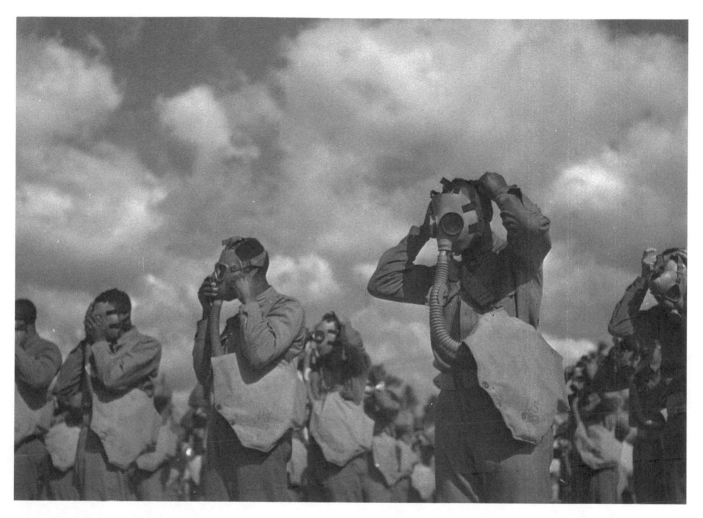

Tar Heels rallied to the flag after Pearl Harbor, while the ever-increasing needs of war saw others drafted. All told, almost 362,500 North Carolinians, including men and women of all races, served during World War II. Many trained in the state, where training grounds for every branch of the service existed. Here, men of Company J, Forty-first Engineers, the first African-American engineer regiment in the then-segregated Army, practice a gas mask drill at Fort Bragg in March 1942.

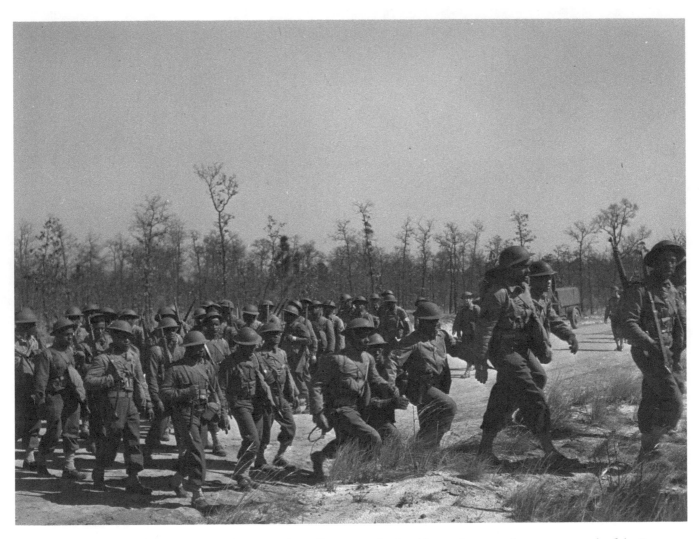

At Fort Bragg in 1942, military-style marching, over long distances and miserable terrain, seemed to occupy much of the Forty-first Engineers' time, as it did for so many Tar Heel trainees.

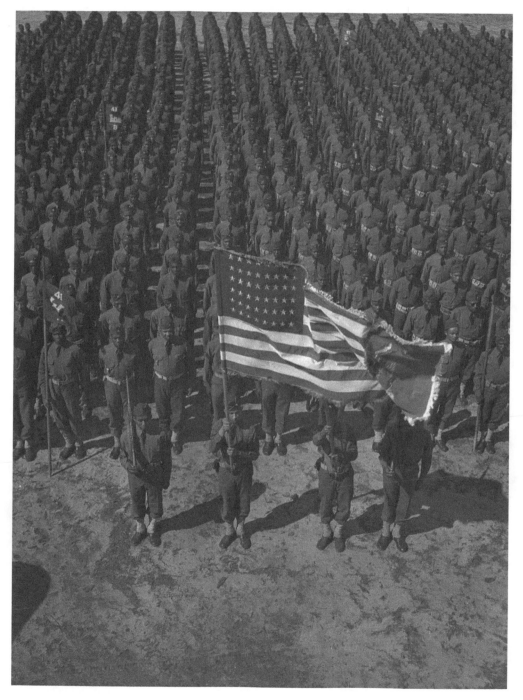

A final parade at Fort Bragg in 1942, and the Forty-first Engineers found themselves ready for deployment. Elements of the unit would serve, some as training cadres, in both the European and Pacific theaters of operation.

Despite a war in progress, some Americans still found time for golf at courses in the Sandhills region of North Carolina, an area of ancient sand dunes dating to the Miocene Epoch (20 million years in the past) when water covered most of the current coastal counties. In locations such as Pinehurst in Moore County, numerous resorts drew, and still draw, golfers from around the world.

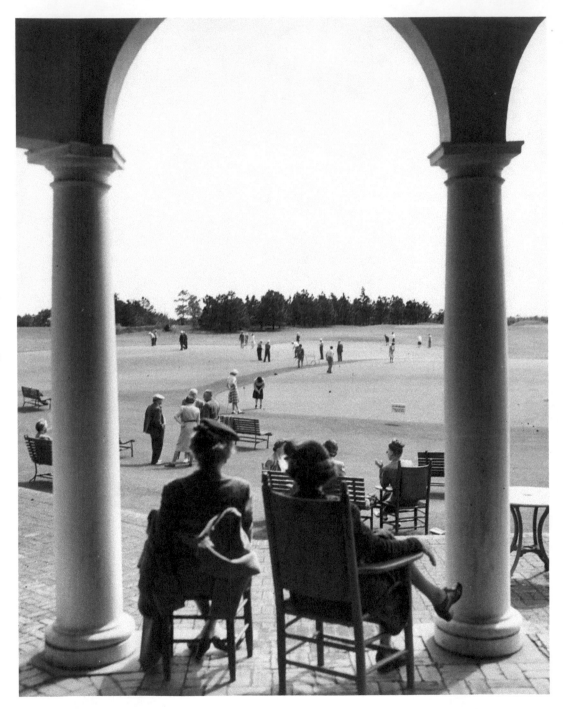

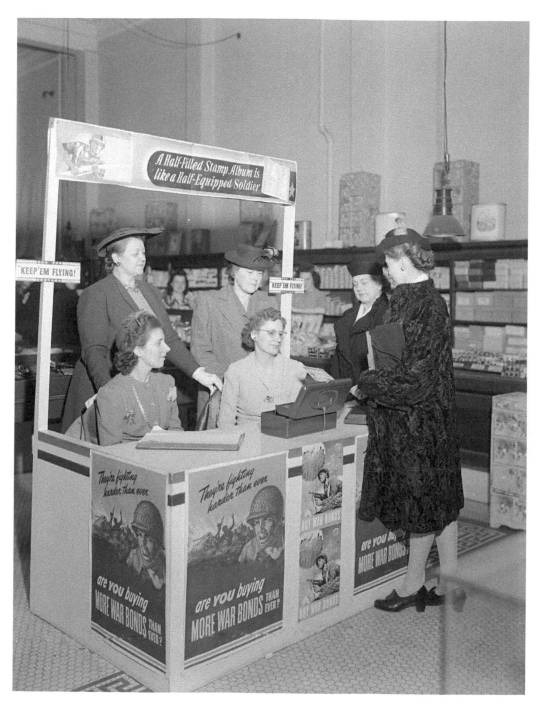

During World War II, many Tar Heels supported the war effort by purchasing war bonds. Stands such as this one in Boylan Pearce Department Store in Raleigh, photographed in 1943 or 1944, sold bonds, as well as stamps that counted toward buying a bond. Bonds were a means of saving money, but by pulling money from circulation, bonds also reduced inflationary tendencies that accompanied rationing.

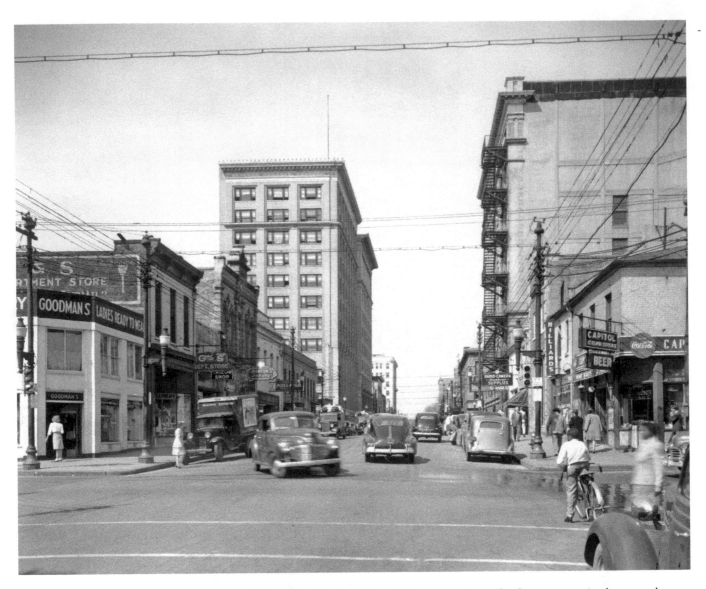

Raleigh's East Hargett Street in 1943: automobiles and pedestrians abound, but young men of military age are in short supply. This shortage affected more than city streets. Women and African-Americans entered the workforce in tremendous numbers during the war. Had they not, the industrial power that made North Carolina the number-one producer of textiles and tobacco products for the military would have slowed or stopped.

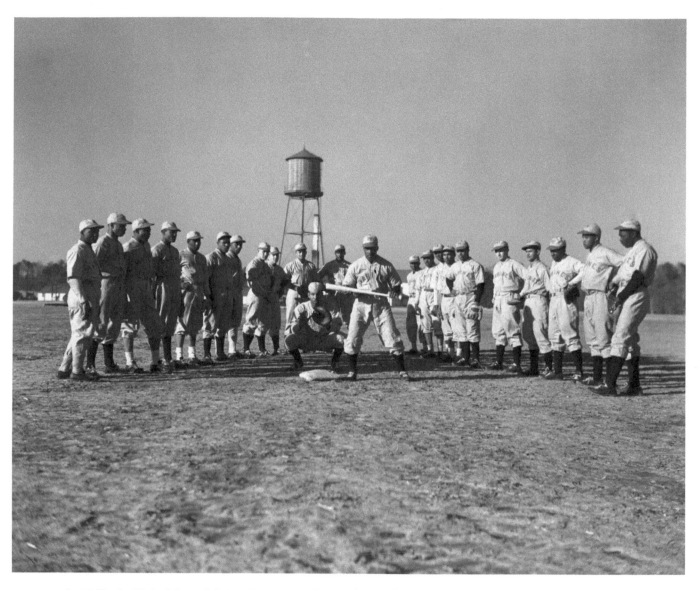

In 1942, the United States Marine Corps opened its ranks to African-Americans for the first time in its history. The 51st Composite Defense Battalion, with 1,200 volunteers, began training at Montford Point, part of the sprawling Camp Lejeune, in September 1942. Though racial friction existed at times, it was not apparent in this interracial baseball team that represented Montford Point in the Camp Lejeune Baseball League in 1943.

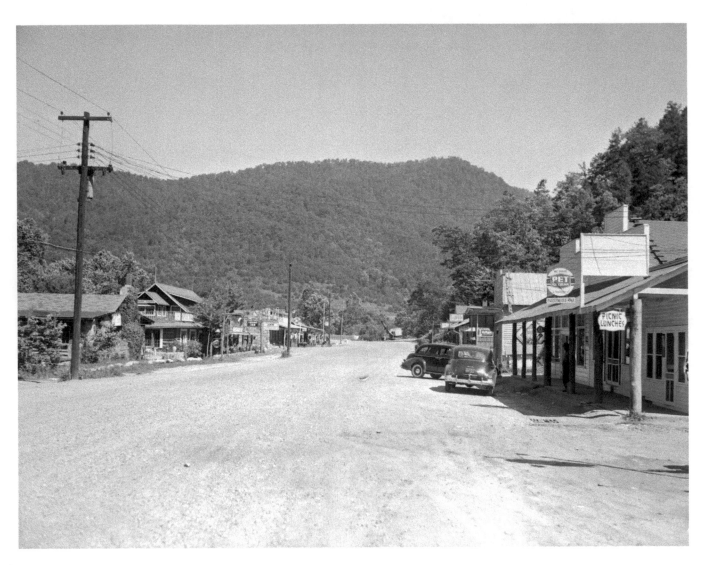

Cherokee, little more than a sleepy village on reservation land and certainly not the tourist destination of today, seemed peaceful in 1944. Like other towns in the state, its loyal sons had eagerly volunteered to fight the forces of fascism.

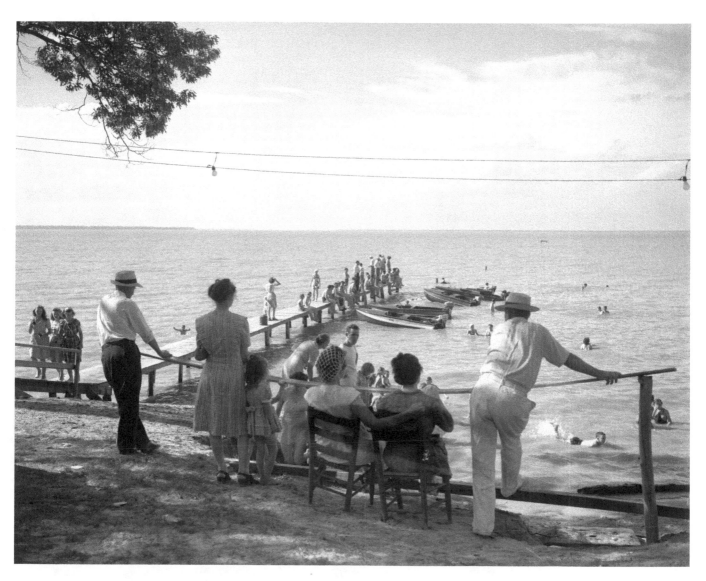

Young and old alike enjoyed Albemarle Beach near Plymouth, Washington County, in July 1945. The war in Europe had ended, but in the Pacific it still raged as Japan grew desperate. How many of these people, staring across the sound, were thinking of someone in a foxhole far away?

By late 1945, the war had reached its conclusion and North Carolina's veterans had begun to return to their homes. This parade, probably for and by elements of the 30th Infantry Division, celebrated the return of this new batch of Tar Heel heroes. The war took a heavy toll. Almost 9,500 North Carolinians did not survive to march in victory parades.

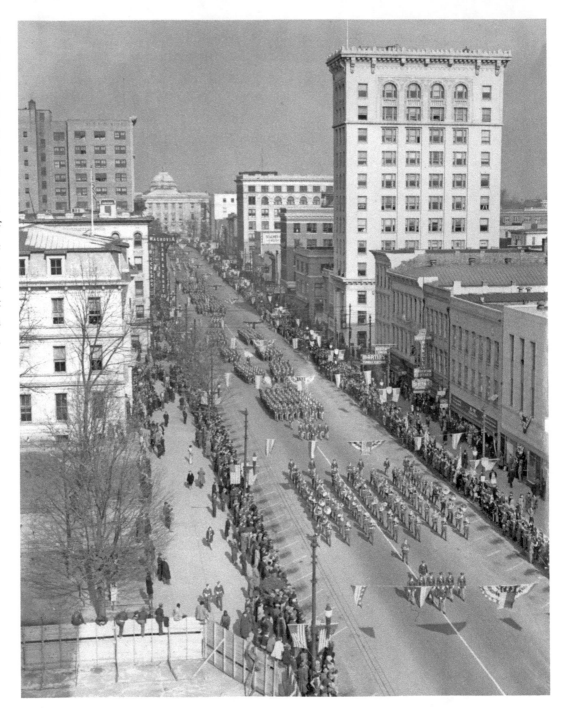

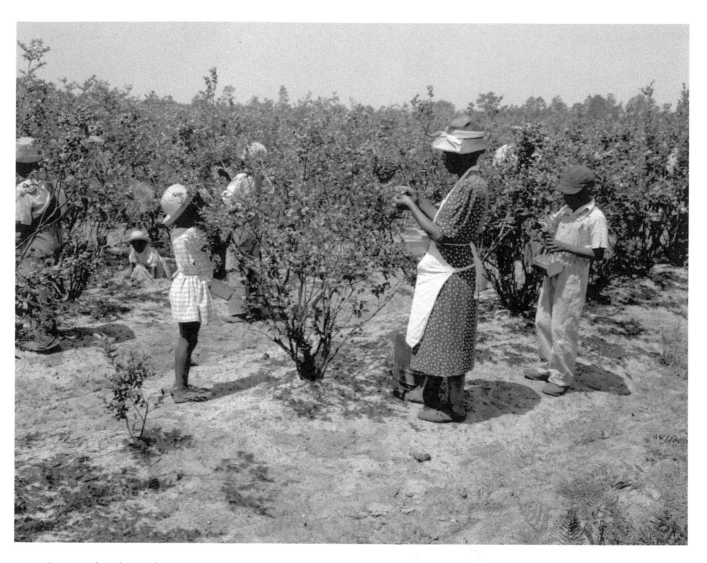

Berry-pickers brave the June sun near Burgaw, Pender County, in 1947. Blueberries, strawberries, and blackberries have long been staples of North Carolina's agriculture. For those who could not afford the "pick-your-own" price at a berry farm, the woods abounded in wild huckleberries and briar berries.

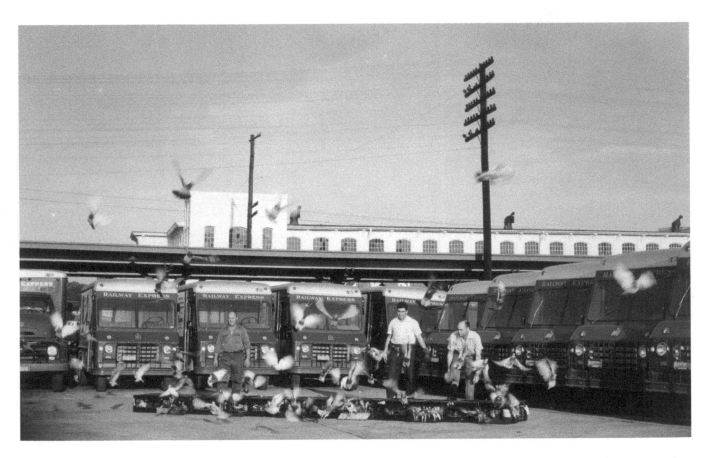

Homing pigeons are released at the Raleigh Seaboard Station in the late 1940s. Pigeon racing continued as a popular pastime after the war, with pigeons timed from their point of release to their return home to their cages.

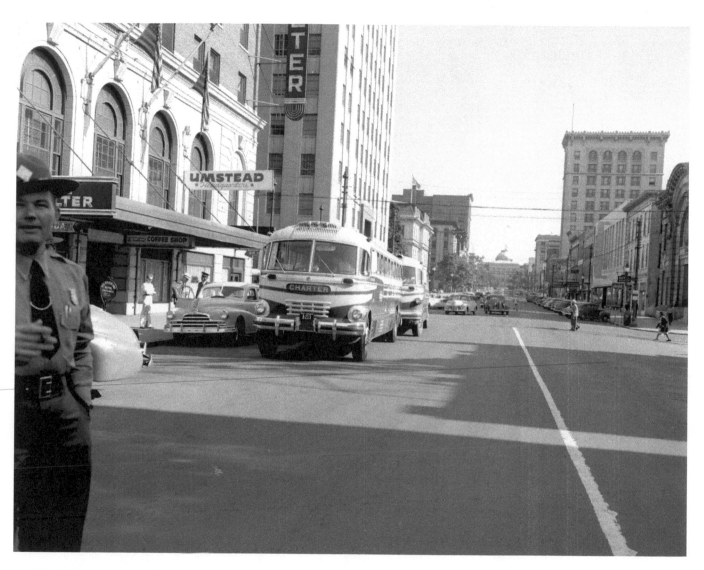

Charter buses stop outside the William B. Umstead senatorial campaign headquarters on Fayetteville Street in Raleigh in 1948. Umstead lost the election to former governor J. Melville Broughton, but won the governorship itself in 1952. Plagued by health problems, Governor Umstead died while in office in 1954, shortly after appointing a committee to look at the effect of *Brown v. Board of Education* and desegregation on North Carolina schools.

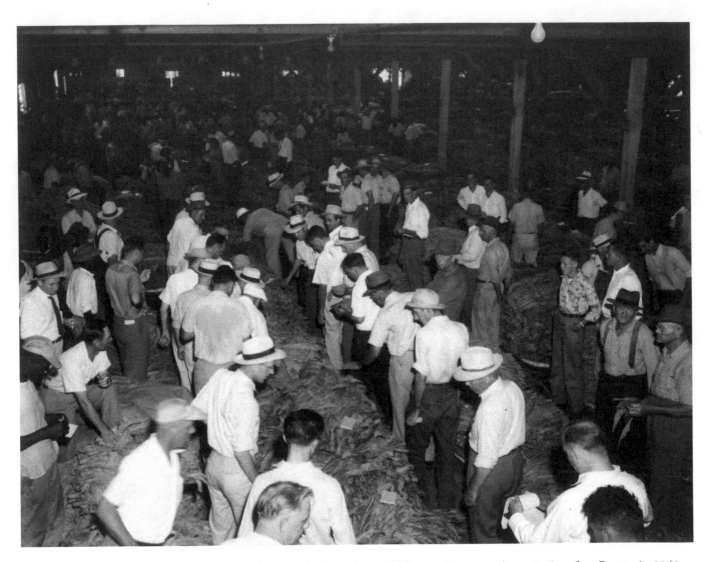

Farmers watch anxiously while an auctioneer chants and tobacco buyers bid at a tobacco warehouse in Beaufort County in 1948. Though industry had exploded in North Carolina by the late 1940s, in large part because of World War II, agriculture remained the dominant economic force in the state.

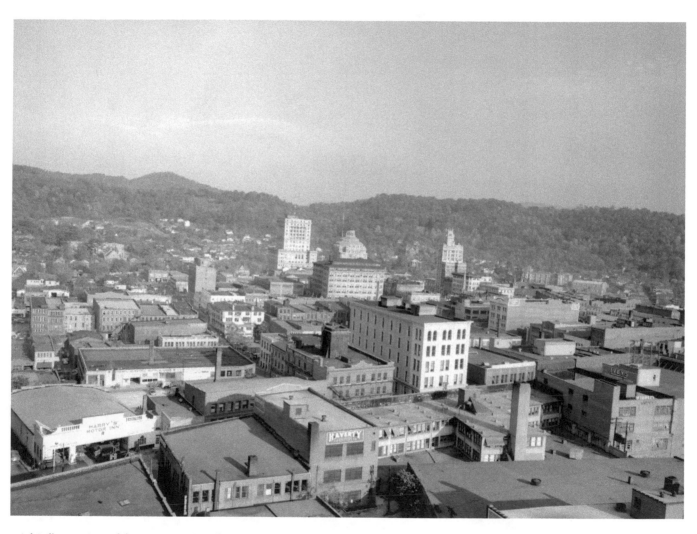

A bird's-eye view of downtown Asheville in November 1949 reveals a successful, growing city and a center of tourism in the state.

In 1948, Asheville hosted the 21st Annual Mountain Dance and Folk Festival in its municipal auditorium. Performers, such as those pictured here, regaled crowds with the distinctive music of the Appalachians.

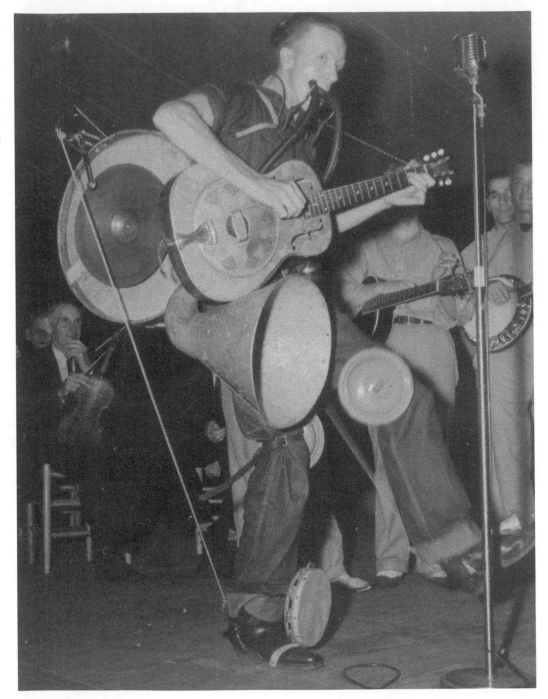

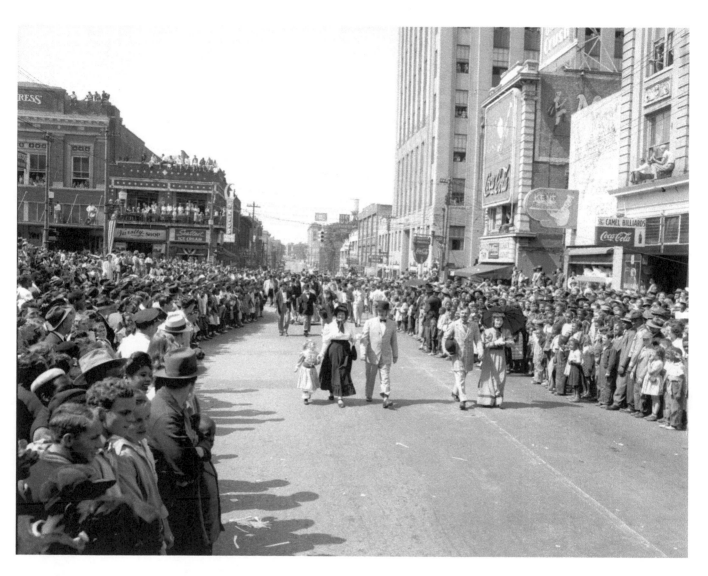

Forsyth County celebrated its centennial in May 1949. Among the events was this parade in Winston-Salem, featuring citizens in period attire. Most of North Carolina had cause to celebrate by 1949; they had survived the Great Depression and another world war. Filled with confidence, they saw a future bright with promise.

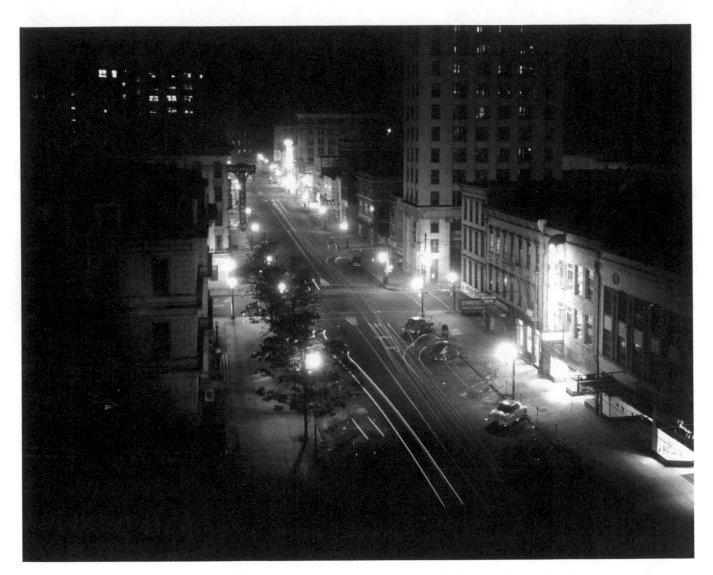

Like many streets in North Carolina, Raleigh's Fayetteville Street may have seemed a little shabby in 1949. Depression and war had siphoned money and effort from maintenance of the infrastructure of the state and its towns, but hopes were high that the rapidly approaching new decade would change all of that.

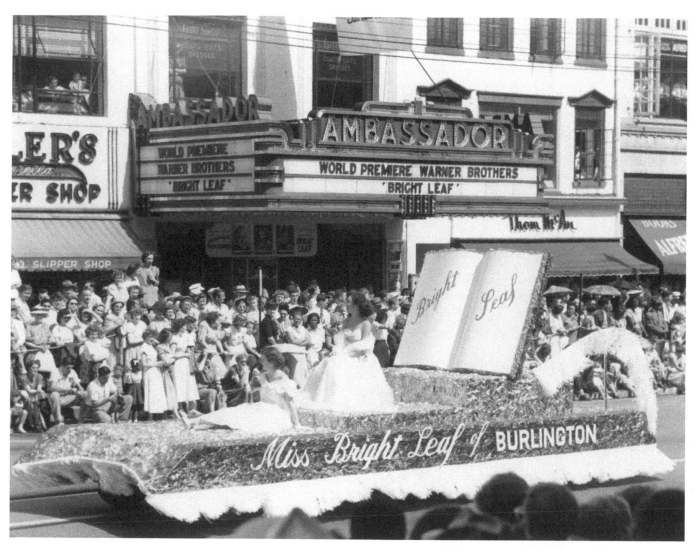

A parade celebrates the opening of the Warner Brothers movie *Bright Leaf* in 1950 in Raleigh. Starring Gary Cooper and Lauren Bacall, the movie is set in 1894 as a tobacco magnate seeks to automate his facilities. North Carolina, heart of the Bright Leaf Belt, gave the movie great reviews.

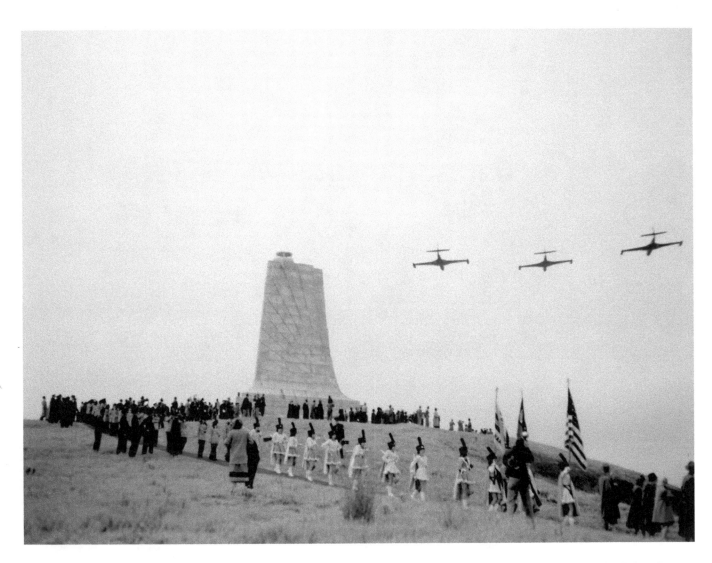

In 1950, the annual celebration at the Wright Brothers Memorial at Kill Devil Hills held a somber note, despite the flyby of F-84Ds. In June of that year, a new conflict had erupted. Within weeks, some North Carolinians found themselves in North Korea and part of a cold war that would drag across the decades, and too frequently burned hot.

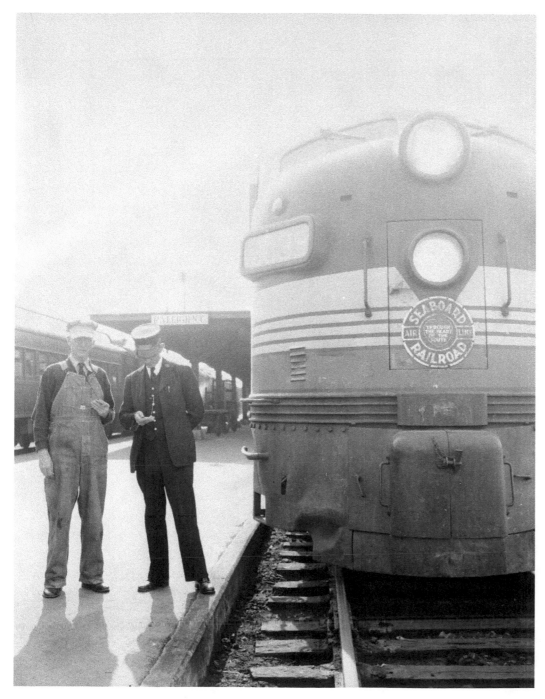

E. D. Boney, engineer, and Sam H. Turner, conductor, check their watches beside their Seaboard Railroad locomotive in Raleigh in 1950. The railroads that opened North Carolina to industrial growth and new markets in the mid-1800s continued to be of vital importance in the 1950s, despite the growth of trucking firms within the state.

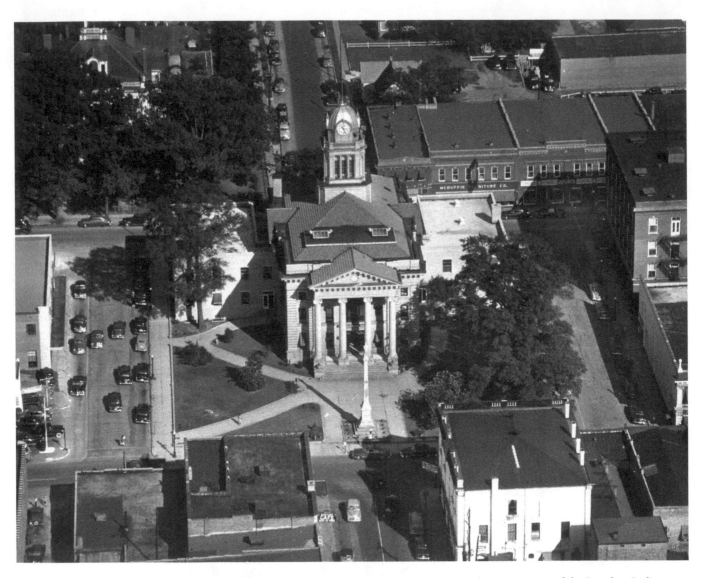

The Robeson County Courthouse in Lumberton is pictured in 1950. Robeson County is home to most of the Lumbee Indian Tribe, who have struggled for years to receive federal recognition of their heritage and status as Native Americans.

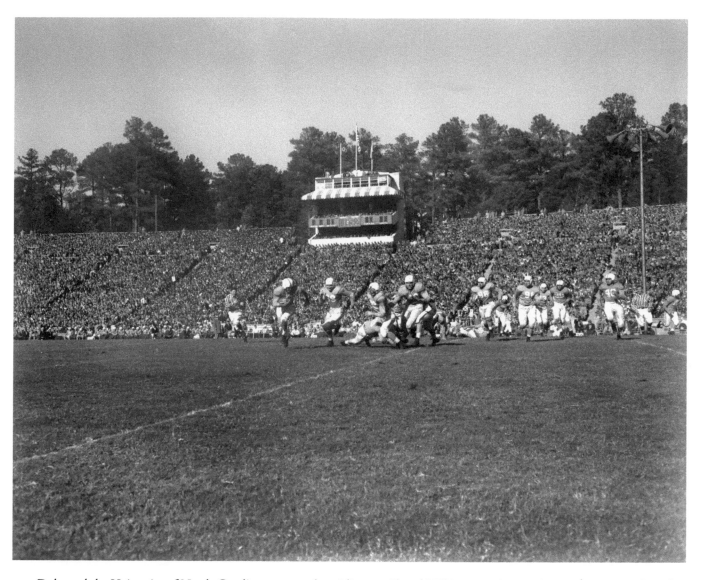

Duke and the University of North Carolina meet on the gridiron at Chapel Hill in 1951, in one of many in-state rivalries that provide intensity to North Carolina's collegiate athletics.

NOTES ON THE PHOTOGRAPHS

These notes, listed by page number, attempt to include all aspects known of the photographs. Each of the photographs is identified by the page number, a title or description, photographer and collection, archive, and call or box number when applicable. Although every attempt was made to collect all data, in some cases complete data may have been unavailable due to the age and condition of some of the photographs and records.

Printed in the USA
CPSIA information can be obtained
at www.ICGtesting.com
JSHW072022140824
68134JS00042B/3739